enduring spirit

Introduction by ISABEL ALLENDE

enduring spirit

Portraits by PHIL BORGES
for AMNESTY INTERNATIONAL

Acknowledgments

I would like to thank the following very gener-
ous friends for their contribution, support, and
guidance:

Abdullahi, Isabel Allende, Ann Burroughs,
Deanne Delbridge, Pier Dicarlo, Helen Garrett,
Romona Gault, Julee Geier, John Klotnia,
Peter Lenges, Chuck Luce, Phyllis Maslin,
Wayne, Maslin, Katie McCoullough,
Megan McFarland, Allan Moores, Negussie,
Rosid, William Schulz, Rachel Simpson,
Christopher Springman, Anne Voegtlen,
Onis Weya, Art Wolf, Ron Zak.

For Nona

–Phil Borges

Amnesty International USA wishes to thank
Phil Borges for putting together this
extraordinary collection of portraits in honor
of the 50th anniversary of the Universal
Declaration of Human Rights. Special thanks
to Isabel Allende for taking the time to con-
tribute her heartfelt introduction. Publication
of this book would not have been possible
without the contributions of Barbara Cox
and Lynn Walker of Linda Jones Enterprises,
Julee Geier, John Klotnia and Pentagram
Design, and Megan McFarland and
Elizabeth White of Rizzoli International
Publications.

–Ann Burroughs and Helen Garrett,
Amnesty International

The names of many of the individuals in this
book were spelled phonetically. Several people
in Irian Jaya and Africa were unsure of their
age. In some cases, friends and relatives
offered their estimations. In other cases,
their memories of significant political and
seasonal events provided clues, and this is
what was recorded.

Amnesty International is a worldwide human
rights organization with members in over 160
countries and territories.

For more information about Amnesty
International worldwide, contact:

Amnesty International
1 Easton Street
London WC1 X8DJ
England
HYPERLINK http://www.amnesty.org
http://www.amnesty.org

For more information about Amnesty
International in the United States, contact:

Amnesty International USA
322 Eighth Avenue
New York, NY 10001
HYPERLINK http://www.amnesty-usa.org
http://www.amnesty-usa.org
1–800–AMNESTY

First published in the United States of America
in 1998 by Rizzoli International Publications, Inc.
300 Park Avenue South, New York NY 10010

Library of Congress Cataloging-in-Publication
Data

Enduring spirit / photographs by Phil Borges
 for Amnesty International ; introduction
 by Isabel Allende.
p. cm.
ISBN 0–8478–2142–0
1. Indigenous peoples—Portraits. 2. Portrait
photography. 3. Human rights—Pictorial
works. 4. Borges, Phil. I. Amnesty
International. II. Title.
TR681.I58867 1998
779'.930590694—dc21 98–7764
 CIP

Front cover: KALIME, 22, AND ALGO, 3.
MURILE, ETHIOPIA (KARO TRIBE),
Page 106.

pp. 14–15: ECHUKA 24, ERAGAI 21
BARAGOI, KENYA (TURKANA TRIBE),
Page 120–121.

Back cover: JUNELLE, 17. LEWISTON,
IDAHO, USA (NEZ PERCE TRIBE),
Page 24.

Design by Pentagram

Printed and bound in Italy

CONTENTS

Where after all do human close to home–so close and seen on any maps of the **where every man, woman, portunity, equal dignity,** Unless these rights have meaning anywhere. **Eleanor United Nations Human**

rights begin? In small places, so small that they cannot be world. Such are the places and child seek equal op- without discrimination. meaning there, they have little Roosevelt, *Chairperson* Rights Commission

introduction by ISABEL ALLENDE

I WAS BORN over a half-century ago in the Southern Hemisphere, before television made its appearance. It was a quiet life in a provincial atmosphere, bounded by the streets of our neighborhood. I thought that everyone was like us, except for the poor people I saw from time to time when we drove out into the country, and who filled me with a mixture of pity and fear. They seemed different, as if they lived in another dimension.

THE FIRST TIME I had any hint of the size and complexity of the world was when one of my uncles returned from India. He was the only person in the family, probably in the whole city, who had traveled so far from home. He had set out in search of the 999 names of God and returned a skeleton with eyes of an illuminati, with no luggage but a few yellowing notebooks in which he had recorded his impressions. We children would sit at his feet and listen to his stories of faraway peoples, amazing customs, landscapes of stunning beauty, and temples of multiple gods. This prodigious uncle was the possessor of a crystal ball. It was, I suppose, only a simple glass sphere, one of those things fishing boats use as floats for their nets, but he convinced us that in it we could see any point on earth. His words were so eloquent and we children were so hypnotized that in fact we did believe we saw reflected in that magical ball all the visions summoned by our uncle. Thanks to him, I developed an uncontainable curiosity about other cultures that has taken me many places around the globe, and today I can say, like the great Mexican writer Octavio Paz, that "it is our ethnic and cultural diversity—our differences in language, customs and beliefs—that provide the strength, resiliency and creativity of our species."

AN INCREDIBLE CAPACITY for adapting to the environment has allowed the human race to live in the eternal ice of the North Pole, the arid dunes of the Sahara, the sweltering forests of the Amazons, or the translucent heights of the Himalayas. Before every challenge of nature, small clans of humans seek a way to utilize the resources at hand and learn to survive. The social organization also must adapt to circumstances. Among the ancient inhabitants of the Arctic, where women were very scarce, offering one's spouse to the traveler so that he would spend a warm and happy night was a gesture of basic hospitality, whereas among the polygamous tribes of the desert, a single glance at another man's woman meant death. How could a man from the extreme north understand the idiosyncrasy of a Bedouin? How to explain to a wanderer of the Sahara what happens in an igloo during the long night of a polar winter?

UNFORTUNATELY, it is this same diversity, the source of the strength that has allowed us to exist for thousands of years, that nourishes intolerance, hatred, and war. We fear everything that is different, and fear turns us into aggressive beasts. With the exception of religious fanaticism, ethnic conflict is the

principal cause of much of the world's hostilities. When the Soviet Union was dismantled, for example, we saw the emergence among nation states of hatred that had lain buried for decades. The atrocities committed in Bosnia against persons who until only shortly before had been neighbors and friends of the perpetrators prove how deeply rooted human aggression can be when turned against those who are not like us. It is much easier to see small differences than to see great similarities. Yet what would humankind be like if we were all the same? We wouldn't be. It's possible that we would have perished as a species. Carried to the extreme, uniformity would finally destroy us.

THE YOUNG PEOPLE of today, unlike the girl I was, do not need the crystal ball of an eccentric uncle to imagine the world; in this communication age, we have instant connectedness. Movies and television programs about foreign cultures have made even the remotest tribes familiar. Today there are very few places on the earth that have not been explored. In 1996, one of the last Amazon tribes still to be exposed to the outside world was spotted from the air. Television and movie cameras recorded the event from helicopters. While the enormous metal birds descended from the sky above Brazil, roaring and stirring up hurricane-force winds, the naked warriors below readied their poisoned darts. A few months later, these same warriors were walking around in tennis shoes, and their blow guns and darts were being sold in the tourist shops of Manáos. I bought some to bring home, and now they hang on my office wall to remind me every day of the existence of peoples threatened with extinction. I am fully aware of the destructive power of cultural penetration, which is the most insidious form of imperialism. What is the solution? It is not a matter of artificially isolating ethnic groups that are not a part of what—with great arrogance—we call civilization. It is a question of moving forward with great caution and respect, so that this encounter will take place on equal terms. It is true that we have science and technology that native societies may lack, but it is no less true that they possess profound spiritual resources, natural wisdom, and knowledge of their physical surroundings that we have lost.

THE MODE OF LIFE of the industrialized countries of the West, this thing we call progress, is wiping out cultures at a terrifying rate. Cultures that have survived for hundreds—sometimes thousands—of years soon will have disappeared. A recent study made by the linguist Ken Hale of the Massachusetts Institute of Technology estimates that 3,000 of the 6,000 languages that exist in the world are fated to die because they are no longer spoken by children. The fragile oral traditions that have preserved ancient knowledge are being lost. When the Amazon tribes forget their languages, their shamans' enormous wisdom regarding medicinal plants will be gone; with the death of the traditions of the

Australian Aboriginal peoples, a powerful psychic practice still unplumbed by modern science will also die. The new generation turns its back on its ancestors, its traditions, its languages, dazzled by the ephemeral brilliance of progress. Young people abandon their families and set out for the great cities, pursuing an illusion. Most of them end up as marginal beings who never truly benefit from the modern world and yet cannot return to their villages, because they no longer belong there, either. As a people, they do not disappear; they live on, but the very essence of their culture is extinguished, leaving them shadows of what they once were and shadows of those they want to imitate in the developed world.

HOW CAN WE STOP cultural imperialism from destroying the precious diversity of humankind? How can we obtain real understanding, and respect for indigenous peoples? If their moral codes are in conflict with ours, how can we resolve the ensuing problems? And at the same time, what can we learn from these cultures? How can we humanize our communities and institutions, save our families, overcome the awful loneliness that progress nearly always carries with it?

THESE ARE THE QUESTIONS that Phil Borges poses to us with his photographs. Behind every face captured by his camera there is a story, a human life different from our own, and equally precious. When you look at these extraordinary portraits, I hope you will see what the photographer has seen: the faces of our brothers and sisters. Individuals whose basic needs are quite similar to our own, who want to be able to raise their families and live their lives in a manner befitting their traditions yet be part of the modern world as well. The 6-year-old Samburu boy in Kenya who is thrilled to go to school; the Tibetan mother who carried her baby over the Himalayas to escape Chinese repression and to give her son a true Tibetan upbringing; the tribesman in Irian Jaya who welcomed Christian missionaries because they helped put a stop to intertribal warfare—these are people with life experiences that are different from ours but with the same emotions and needs that we have.

TO HELP INDIGENOUS PEOPLES preserve their cultural heritage, we must first recognize its value. Borges, who has spent much of his life traveling to this vanishing world, recounts that he will never forget his first trip to Mexico in the late 1960s. There, any pretext served as a reason for a fiesta. People had time to gather together in the markets during the day and in the plaza at night, singing, making music, celebrating. Children ran around freely, playing and shouting, with no one watching over them, because there was no danger. Old people sat talking in groups, while adolescents strolled around arm in arm. He tells how when he returned to the United States, he saw the terrifying loneliness of his culture from a new perspective.

When he got onto a bus, he noticed the silence, the space among the riders, their systematic way of avoiding eye contact and, with greater reason, physical contact. In any public place we see the same thing; every person seems isolated inside a magnetic field. We are alone in a crowd. Between 1960 and 1990, the number of adults living alone tripled in the United States, and when the state and institutions fail, as so often happens, the weak are the first to suffer the terrible consequences. Every year an alarming number of solitary elderly people die without anyone even being aware of it. Their deaths are discovered when the neighbors complain about the smell! I wonder how many American children have never even seen their grandparents. We have lost a lot with progress.

IN MOST OF the so-called Third World, large families are the rule. Few people would survive otherwise. One's life depends on relationships, on that web of connections composed of relatives, friends, and neighbors. Every society must develop mechanisms for protecting that part of the population that needs the greatest help, from children and the aged to women, the ill and disadvantaged, and the most desperately poor. In many parts of the world that protection is provided by people, not the state. Social security is guaranteed by the family, not by a plan or an institution, as happens in developed countries, where we must pay for the care of children, our elderly, the weak and ailing, and where we also pay for emotional assistance, even companionship. In societies other than ours, that means the elders have a respectable position in the community: their experience and wisdom are treasured. It also means that in extended families children are the responsibility not solely of their parents but of their many relatives and, in the larger sense, the village. Borges says that in Africa he photographed a woman who nursed her baby, then passed him to another woman, who also gave him her breast and in turn passed him to a third mother, who fed him and rocked him until he fell asleep. Children carry their younger brothers and sisters on their backs. There is so much touching! Before coming to the United States, I had never heard the term "terrible twos" used to refer to a child of that age, and I didn't know that adolescence was a long period of martyrdom. In growing up, my children passed through stage after stage without any dramatic crisis, and when a crisis did arise it was diffused in the context of a large family in which each individual had his or her own problems and there were many people to help.

IT WOULD BE NAIVE to suggest that at the threshold of the year 2000, when the pace of life is every day faster and more intense, we should go back to tribal traditions and large families as the solution to individual isolation and the cruelties of our social system. Most members

of indigenous and endangered cultures live for generations in the same spot; we are constantly on the move. It is estimated that Americans move—often out of state—an average of once every five years. We lack the "sense of place" that characterizes indigenous peoples, and this is not something we can acquire artificially, by simply willing it. But now that it is lost to us, we should at least admire it and try to preserve it in other societies.

ALTHOUGH THERE ARE many positive aspects of these cultures, we should not ignore the problems. As a woman, I am horrified by the treatment my sisters receive in some tribes: they suffer genital mutilation; their fingers are amputated in mourning rituals for dead relatives; they are sold as slaves; they are beaten in male-initiation rites; they are forbidden to marry again if widowed, to be educated, to possess goods, even to move about freely. There are more women who have never gone farther than a hundred meters in any direction from their huts, others who spend their lives shrouded from head to foot in a mantle with only a hole at the level of their eyes. Everywhere in the world, women are the poorest of the poor.

I COME FROM A LARGE FAMILY in which interpersonal connections are very strong. I grew up following a strict code of honor, within a system of traditions that today is considered antiquated. It was expected that each member of my family would be responsible for all the others; that no one would move up without helping those left behind; that no one would run the risk of doing anything that would stain the honor of our name. We had the responsibility to look out for anyone who shared our blood, even if the relationship was a distant one. Now that I live in the United States, I can see that this is not always an advantage. To develop my personality fully, I had to abandon my "tribe" and my "village." In my case, the terms are exaggerated, but they illustrate my point. During the time that I was watched over and directed by my relatives, always fulfilling my duties as a daughter, mother, wife, sister, even as the eldest grandchild of my grandfather, I could not really break loose and fly. Despite my rebellion against the patriarchal system into which I was born, I would never have cut myself off from my family voluntarily. It took a military coup that unleashed brutal repression to cause me to leave my country. Alone, without roots and in a foreign land, I tested my creativity for the first time and found within me a strength I did not know I possessed. My calling as a writer was born of exile. By offering this personal example, I want to illustrate that the system of community, which has managed to preserve the indigenous and endangered cultures photographed by Phil Borges for this book, has the drawback of limiting personal aspirations and freedoms.

UNFORTUNATELY, all too frequently indigenous peoples and endangered groups,

because they are marginalized by modern society and because they lack political or economic power, are prey to the greed and negligence of governments and corporations who consider them irrelevant. As a consequence, these people are subjected to the worst abuses of human rights: their villages and temples are destroyed; their lands are invaded; their freedom is taken from them; they are subjected to every humiliation and form of violence; they are obliged to abandon their customs, their languages, and often their religious beliefs and to become refugees and beggars. Day after day, these peoples are losing the battle to preserve their identities. Day after day, the human race is losing another portion of the diversity that has been the source of its strength and resiliency.

IF I HAD MY UNCLE'S crystal ball and could see into the future, I would wish for the next millennium to be an era of peace. Bending over the crystalline sphere, I would hope for a world in which there is a true community of peoples, nations, and tribes, where human rights apply to all. I would hope for a future when we will beautify the Earth, this magnificent blue marble dancing through the astral space in which it is our fate to live. The richness of the human race lies in its diversity. Progress is not based on uniformity; rather, the opposite is true: the preservation of diverse cultures brings progress. Life is pluralism, distinctness, transformation. Only death is the same for all.

IN THIS BEAUTIFUL BOOK Phil Borges celebrates, with his images and stories, life as it is lived and shared in so many places on our fragile and beautiful planet. How fitting for these images to be associated with the 50th anniversary of the Universal Declaration of Human Rights, the first document that recognizes and protects our differences, the first document to honor the inherent dignity of all peoples.

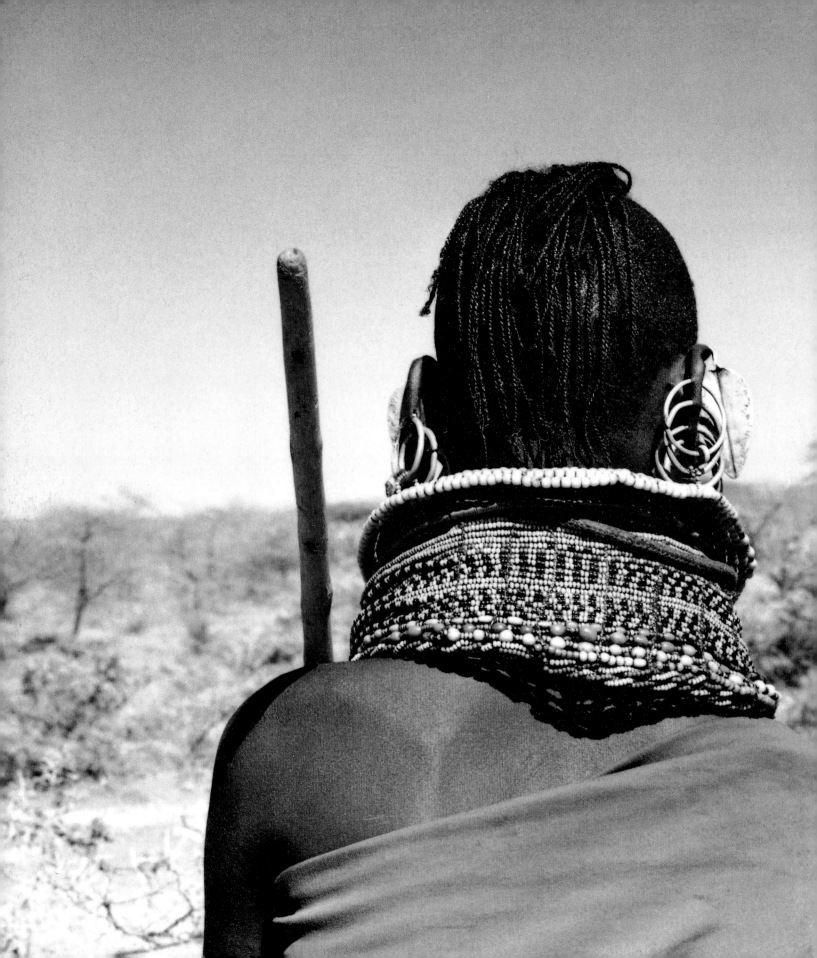

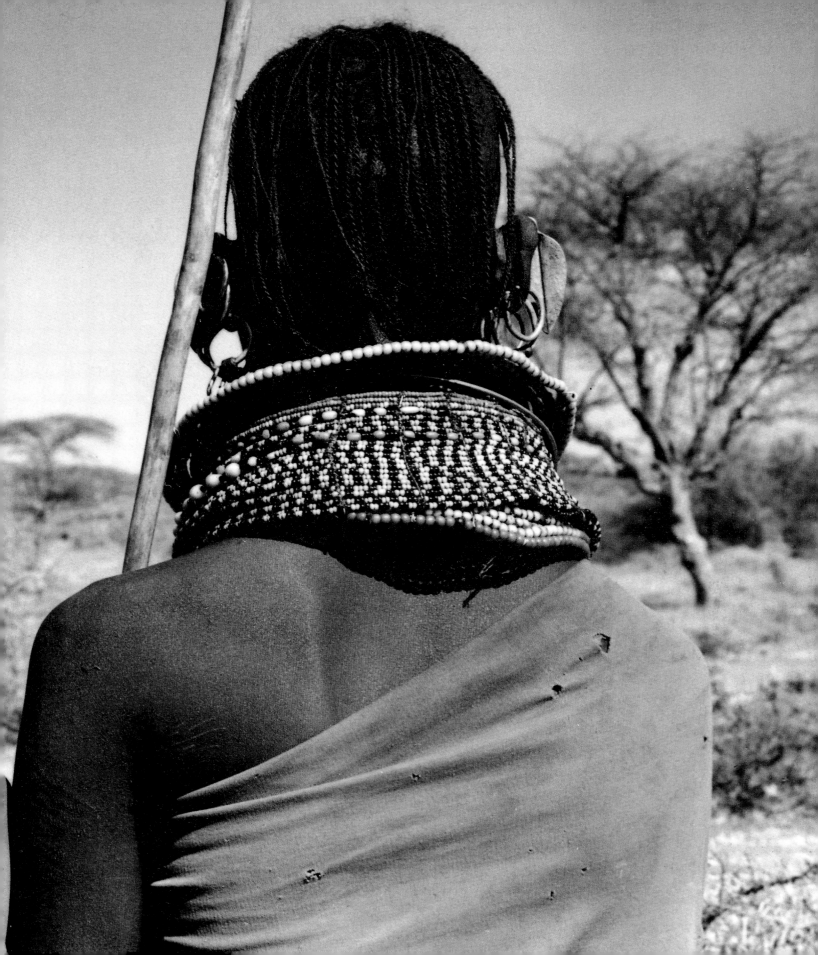

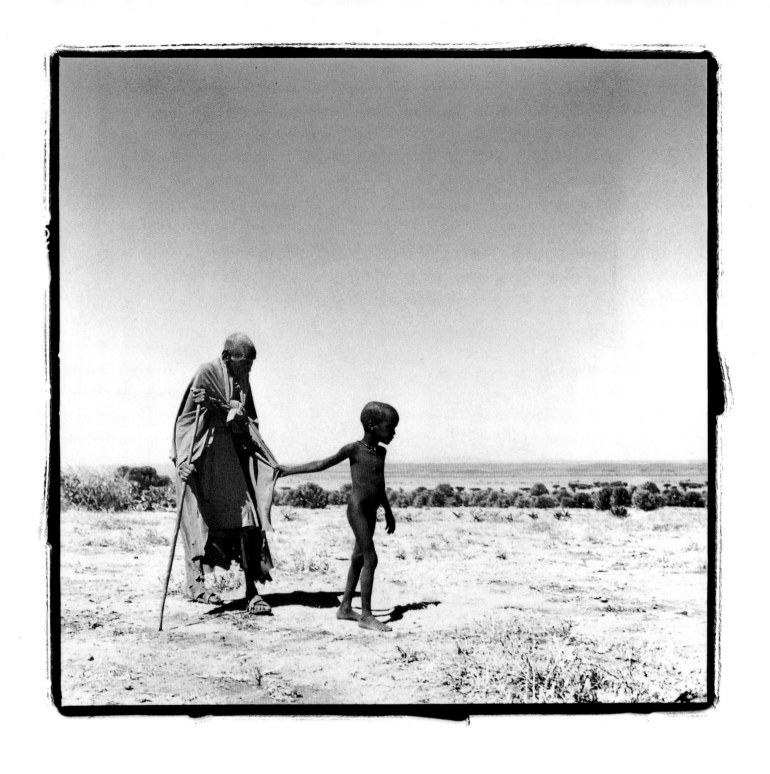

Every morning, 7-year-old Ipipa leads his blind great-grandmother, Lamalai, on her daily walk in Kenya's remote Northern Frontier District.
Samburu Tribe

16

17

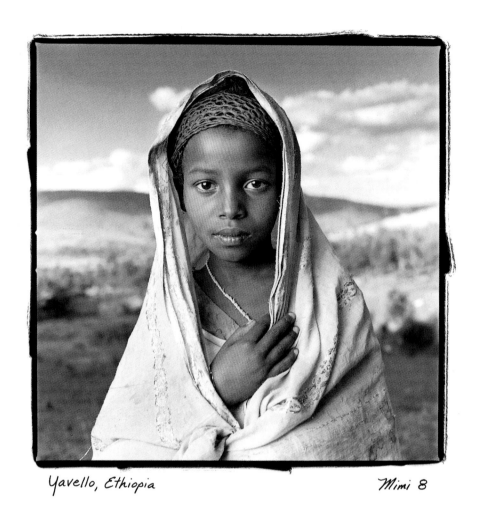

Yavello, Ethiopia Mimi 8

MIMI 8, YAVELLO, ETHIOPIA As one of five children, Mimi spends most of her day collecting firewood and water. Her parents will soon choose which one of their children will go to school. Mimi said she would love to go but doesn't believe she will: not only is her help crucial to the family's survival, but parents also customarily choose boys over girls to receive an education. *Borana Tribe*

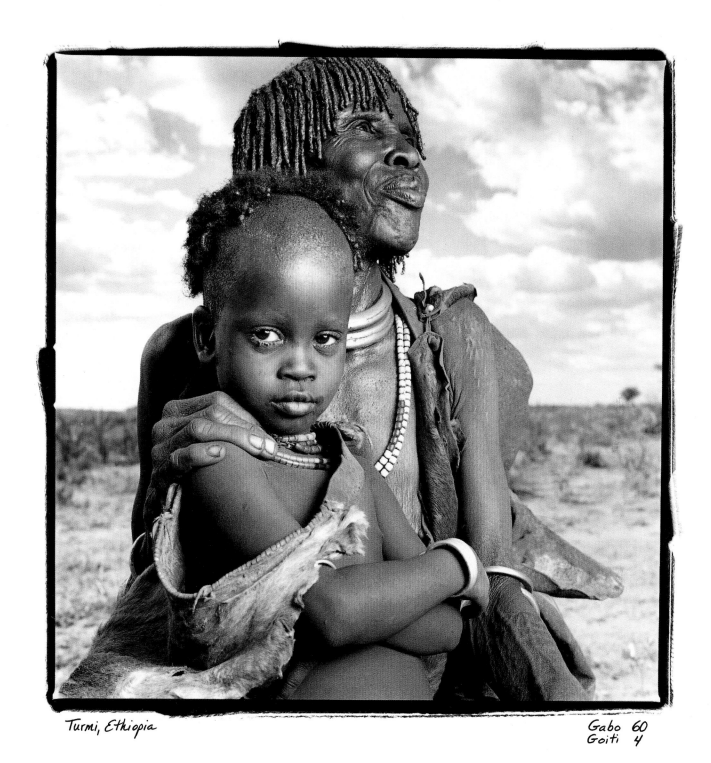

Turmi, Ethiopia

Gabo 60
Goiti 4

GABO 60, GOITI 4, TURMI, ETHIOPIA Gabo was helping her great-granddaughter Goiti collect firewood when I first saw them.
Less than a year before, Goiti's father had died of malaria. Her mother, who by custom is not allowed to remarry, is now responsible for grazing their
goats as well as cooking, caring for her children, and collecting firewood and water. Gabo, a widow herself, recently moved in with
the family to help share the workload. *Hamar Tribe*

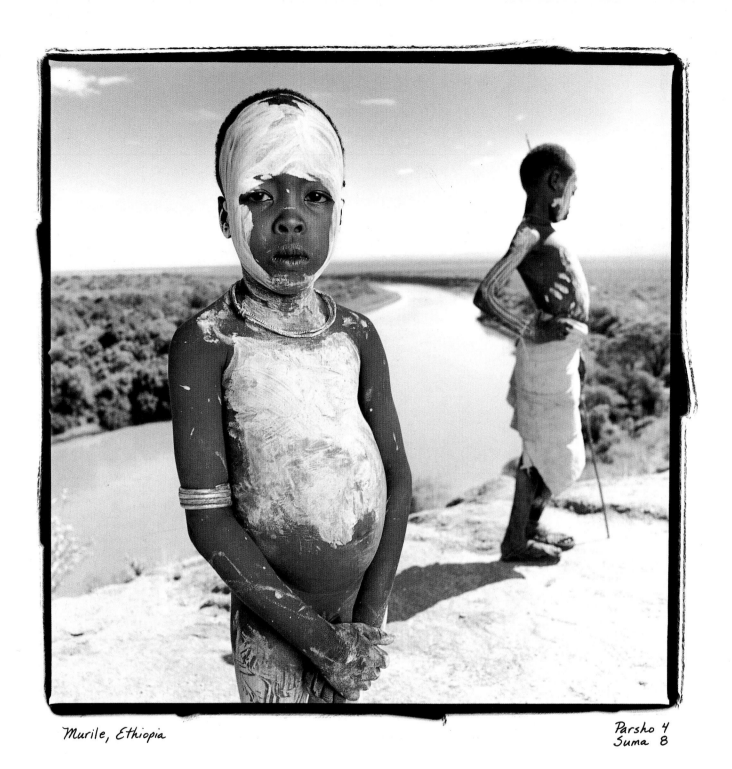

Murile, Ethiopia

Parsho 4
Suma 8

PARSHO 4, SUMA 8, MURILE, ETHIOPIA Now that the maize is ripening, Parsho and Suma have been given the responsibility of guarding
one of the communal fields from birds and baboons. Because of this year's drought, the crop is sparse and their job is critical.
Suma said that a group of baboons had tried to raid the field a short time ago, but he and Parsho screamed until the warriors came.
Baboons have been known to carry off children Parsho's age. *Karo Tribe*

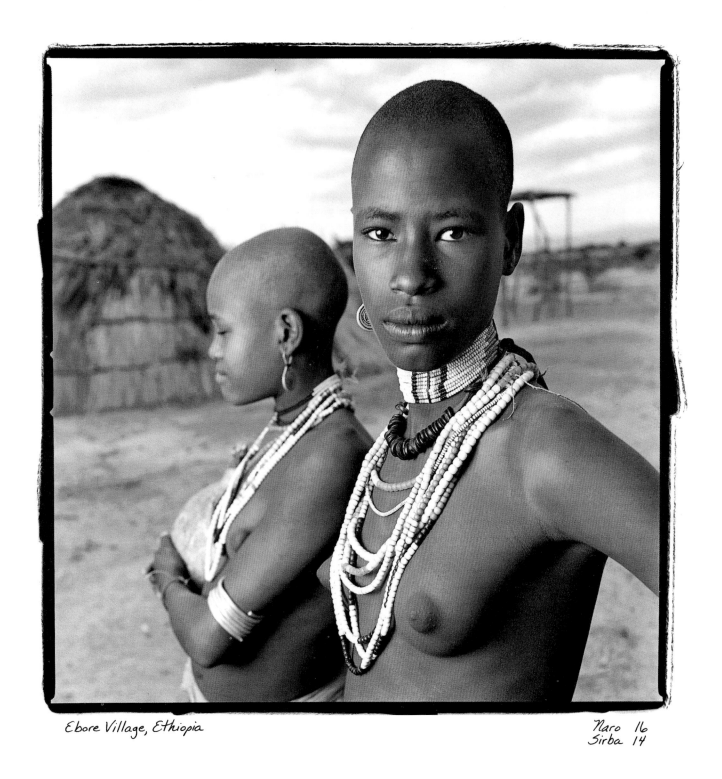

Ebore Village, Ethiopia

Naro 16
Sirba 14

NARO 16, SIRBA 14, EBORE VILLAGE, ETHIOPIA It is the custom for Ebore girls to shave their heads until they are married. Naro and Sirba spend most of the day fetching water and looking after the cattle. However, Naro has the added responsibility of taking care of her grandmother, who has been ill for several months. Because of her grandmother's illness, Naro's marriage has been delayed. Sirba plans to marry in a few weeks. *Ebore Tribe*

Tana Toraja, Indonesia *Rudi 7*

RUDI 7, TANA TORAJA, INDONESIA Rudi's small village is a day's walk from the nearest road in the mountains of Sulawesi. He took me to his one-room house, where many of the villagers were crowded around a small television, watching Mike Tyson fight Evander Holyfield. After my arrival, all eyes were in constant motion between me and the television set. As Tyson bit his opponent, I couldn't help wondering what these people thought of me and my culture. *Toraja*

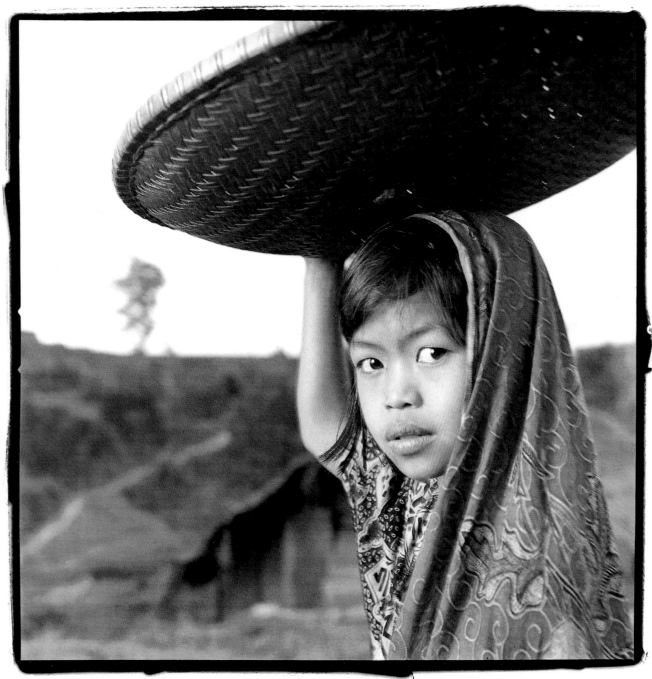

Tana Toraja, Indonesia

Lena 9

LENA 9, TANA TORAJA, INDONESIA Lena comes from a family of six children; however, only she and her 4-year-old sister remain at home. Her older brothers have all left Tana Toraja to seek employment in the larger cities of Indonesia—a typical pattern for Toraja's young people since the late 1960s. In a society where family continuity and closeness are still intensely valued, this departure of a whole generation of youth has been quite devastating. *Toraja*

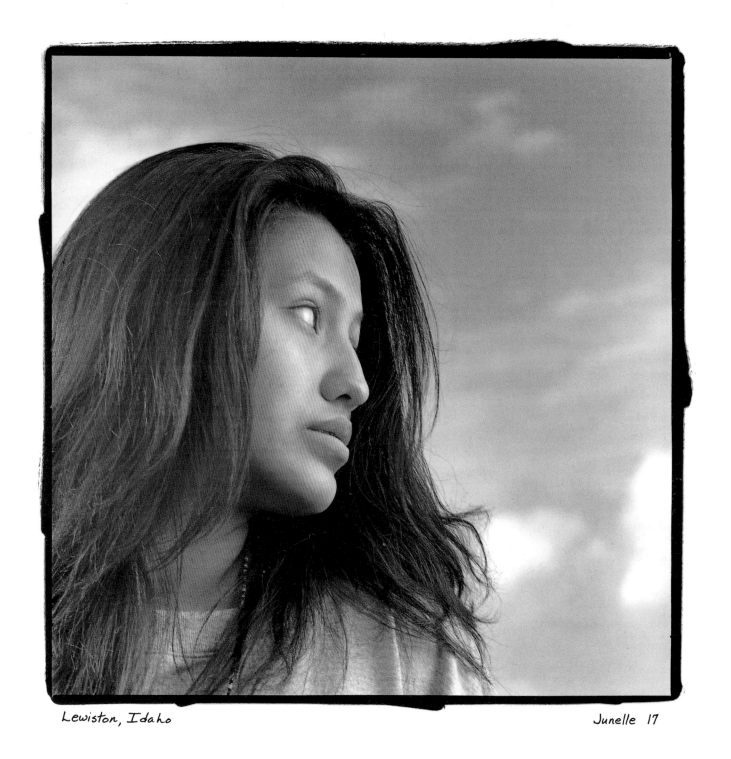

Lewiston, Idaho

Junelle 17

JUNELLE 17, LEWISTON, IDAHO (UNITED STATES) Junelle's parents first started taking her to powwows 14 years ago. She quickly learned both traditional and fancy dance styles and was just named Miss Looking Glass at the annual Four Nations Powwow in Lewiston. She said that there were very few powwows when she started dancing, but now all that has changed. "The powwow is like a giant family reunion; it is very communal and sacred." *Nez Perce Tribe*

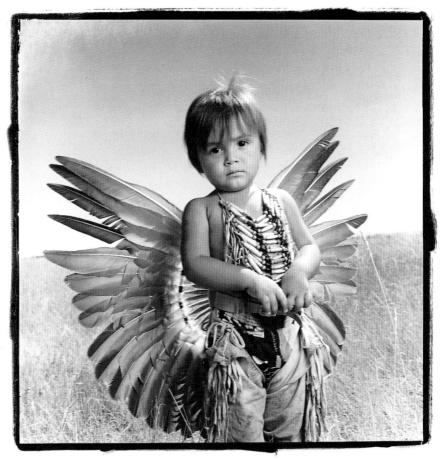

Crow Agency, Montana Joseph 2

JOSEPH 2, CROW AGENCY, MONTANA (UNITED STATES) Joseph traveled with his parents all the way from Window Rock, Arizona, to dance in the Crow powwow in Montana. He actually started dancing in powwows when he was just 9 months old. As the first in his immediate family to participate in traditional Navajo dance, Joseph represents a general return to Native American culture. *Navajo Tribe*

Tana Toraja, Indonesia

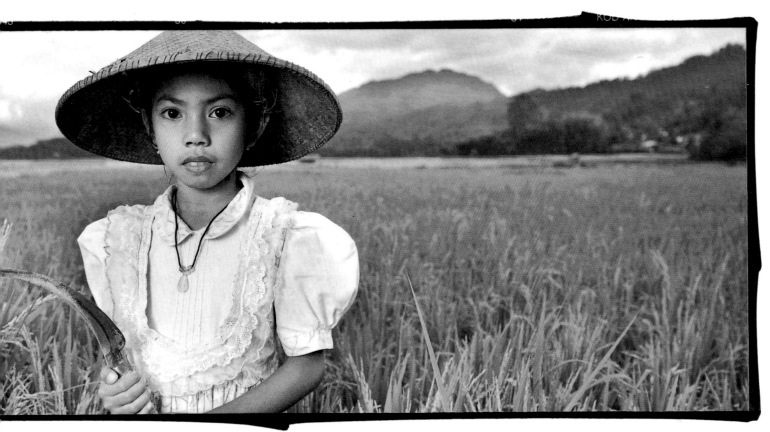

Irma 9

IRMA 9, TANA TORAJA, INDONESIA Irma had just arrived home from school when I saw her. She set down her books, picked up a scythe, and waded into this large rice field. Within minutes, she was joined by some 40 men, women, and children from her village. They started from the edge of the field and worked toward the center. In less than an hour, they had cut and stacked the entire crop. Most of the farming is done collectively in Tana Toraja. *Toraja*

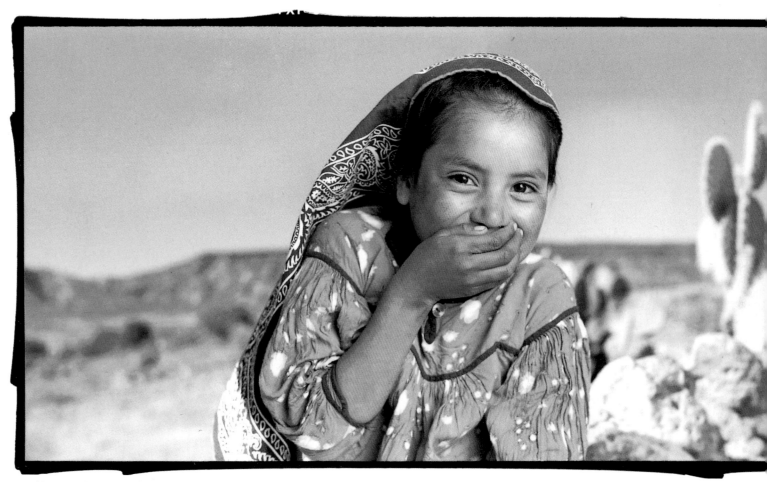

Huejuquilla El Alto, Mexico

SILVIA 9, HUEJUQUILLA EL ALTO, MEXICO Silvia and her sister had just made the difficult 10-hour trip from their mountain home in Santa Catarina to bring their beaded wristbands to sell at the Huichol Center for Cultural Survival. They turned in 12 wristbands and picked up enough beads to keep them working several weeks more. The previous month, their beadwork had appeared as accessories on top fashion models in *Elle* magazine. After I showed Silvia a Polaroid of herself, she couldn't stop laughing. *Huichol*

Silvia 9

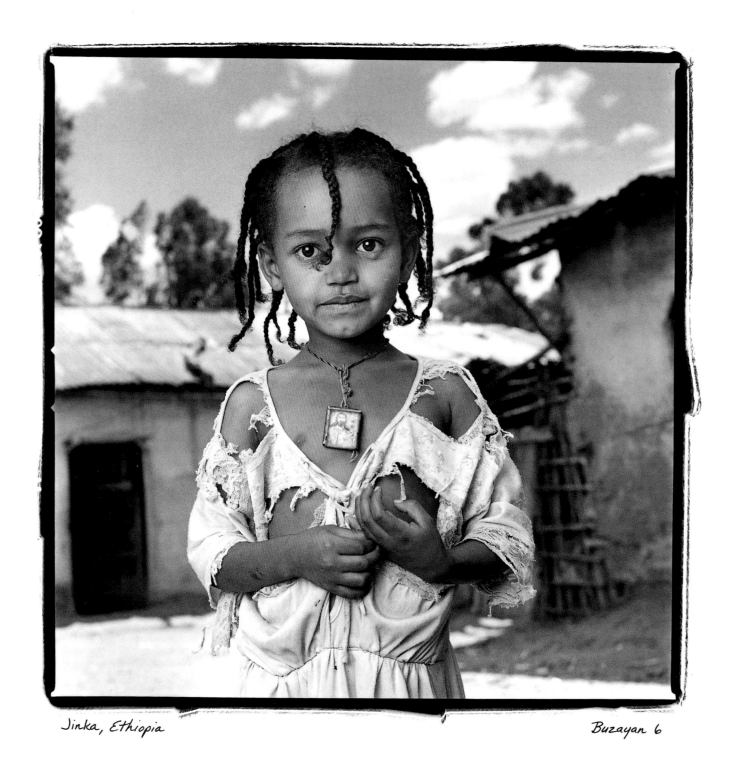

Jinka, Ethiopia

Buzayan 6

BUZAYAN 6, JINKA, ETHIOPIA Buzayan lives with her mother and her three older sisters in a small Ethiopian village. Her father took a job as a policeman in a neighboring town and later abandoned the family for another woman. Even though it is very expensive for her, Buzayan's mother is committed to keeping all the children in school. When I asked Buzayan about kindergarten, she squealed with delight and started jumping up and down. *Bana Tribe*

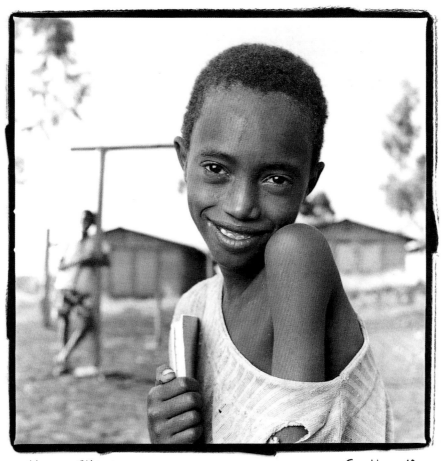

Konso, Ethiopia Gambino 10

GAMBINO 10, KONSO, ETHIOPIA Gambino is an orphan who lost his mother to malaria two years ago. As a result, he is homeless and looks for
odd jobs in order to feed himself. I was told that he showed such a strong desire to go to school that the director has allowed him
to attend for free. As I took his photo, a crowd of children gathered and watched intently. Three weeks later, when I passed through his little town,
I was met by kids chanting, "Gambino! Gambino! Gambino!" He was now a celebrity. *Konso Tribe*

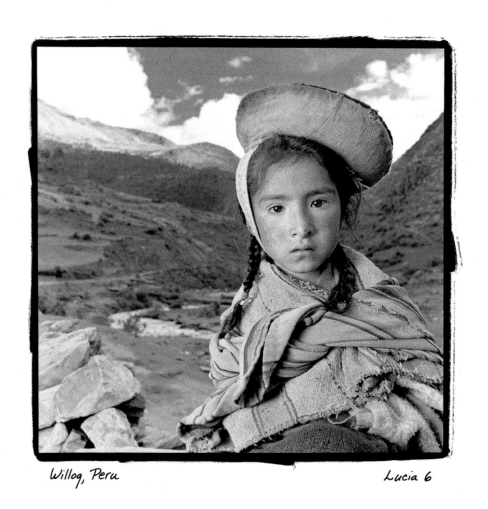

Willoq, Peru Lucia 6

LUCIA 6, WILLOQ, PERU According to her first-grade teacher, Lucia is rather shy and does not sing and dance as readily as her classmates. Next year will be critical for her. At that time, her classes will begin to be taught in Spanish instead of her native language, Quechua. In mixed classes Quechua children struggle to keep up with their Spanish-speaking schoolmates. Many Quechua children quit school at this time out of frustration. *Quechua*

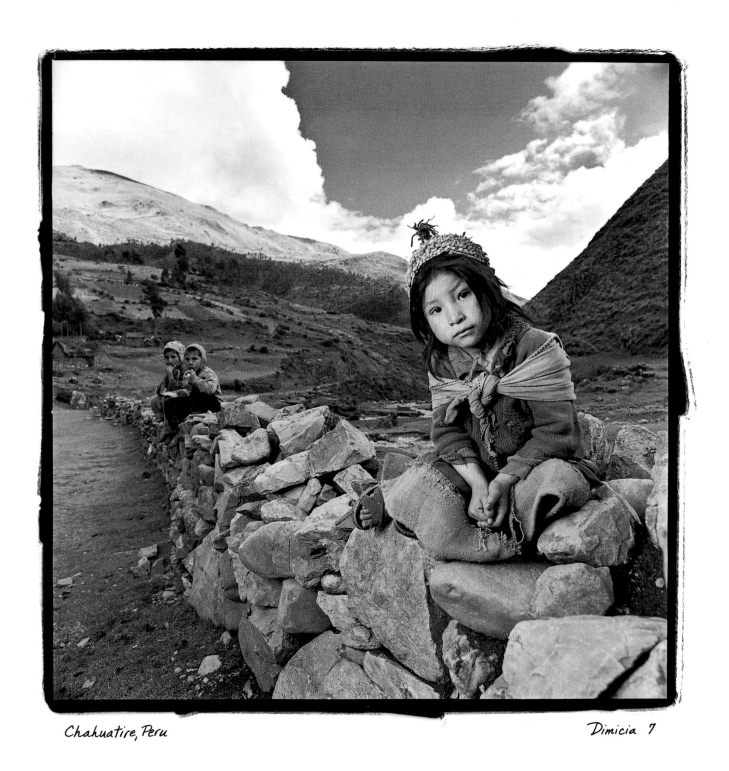

Chahuatire, Peru *Dimicia 7*

DIMICIA 7, CHAHUATIRE, PERU Dimicia's mother was instrumental in establishing a school in their small village. About the time Dimicia started first grade, her 9-year-old brother began working as a porter on the Inca Trail. For less than three dollars a day, he carries some 40 pounds of camping equipment for tourists making the popular four-day hike to Machu Picchu. *Quechua*

Tana Toraja, Indonesia

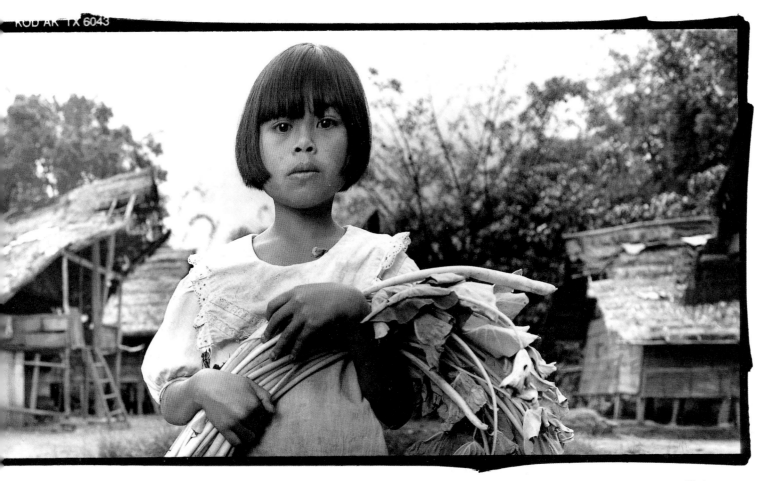

Rida 12

RIDA 12, TANA TORAJA, INDONESIA Rida had just spent all morning working in the community garden. She told me that her mother, her grandmother, and her great-grandmother were born in the *tongkonan* (house) right behind her.

Although her family is very poor and hasn't been able to keep its *tongkonan* in good repair, the house plays a central role in her family's identity.

In fact, Torajans trace their ancestry and consider themselves linked to others through a particular *tongkonan. Toraja*

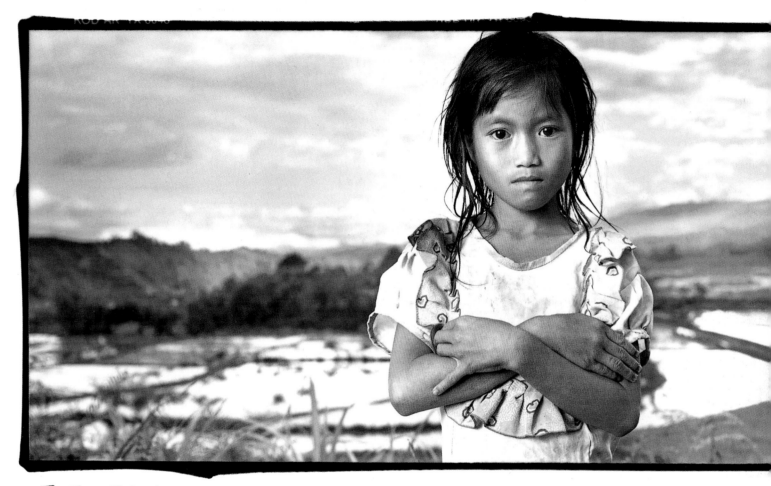

Tana Toraja, Indonesia

UTTI 9, TANA TORAJA, INDONESIA Utti and her siblings—six brothers and four sisters—live with their parents near the village of Mamasa in the mountains of western Tana Toraja. The family belongs to a small faction of Torajans who have not yet abandoned their traditional religion, Aluk, by converting to Christianity. Known as the "ways of the ancestors," Aluk provides the framework for a comprehensive integration between the spirit world and the world of the living. On an almost daily basis, Utti's family exchanges blessings and gifts with the spirits of its ancestors. *Toraja*

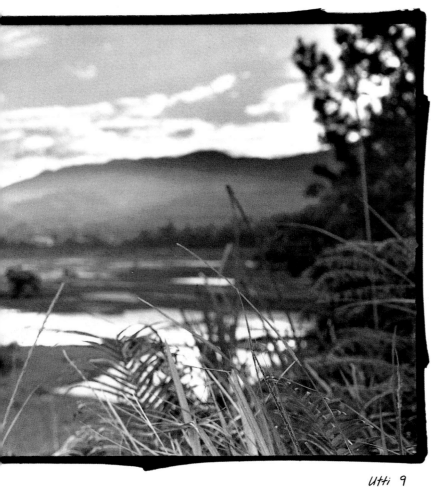

Utti 9

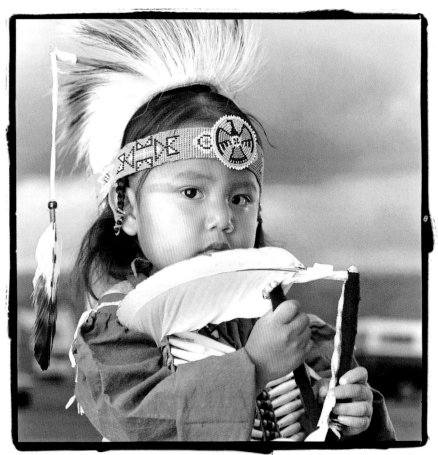

Lewiston, Idaho *Alan Slickpoo III 18 mos.*

ALAN SLICKPOO III 18 MONTHS, LEWISTON, IDAHO (UNITED STATES) I watched Alan as he danced tirelessly for nearly an hour at a powwow, working his way in and out of the adult dancers. His mother told me, "He has been dancing since he was able to walk. He feels the drums and, bang, he's out there dancing. It's wonderful. Old ways are being remembered and taught to the young. We're coming back." *Nez Perce-Yakima tribes*

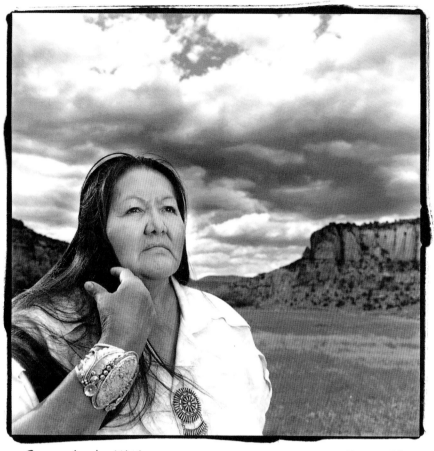

Canyonlands, Utah

Bessie Cly

BESSIE CLY, CANYONLANDS NATIONAL PARK, UTAH (UNITED STATES) Bessie comes from a long line of successful Navajo silversmiths. I met her and her family outside Canyonlands National Park, where they sell their jewelry to visiting tourists. The Navajo learned the craft from Spanish silversmiths along the Rio Grande in the mid-1800s. For years, they were content to make the jewelry for their own adornment, until Anglo-Americans discovered their work in the early 1920s. *Navajo Tribe*

Nyiru Range, Kenya

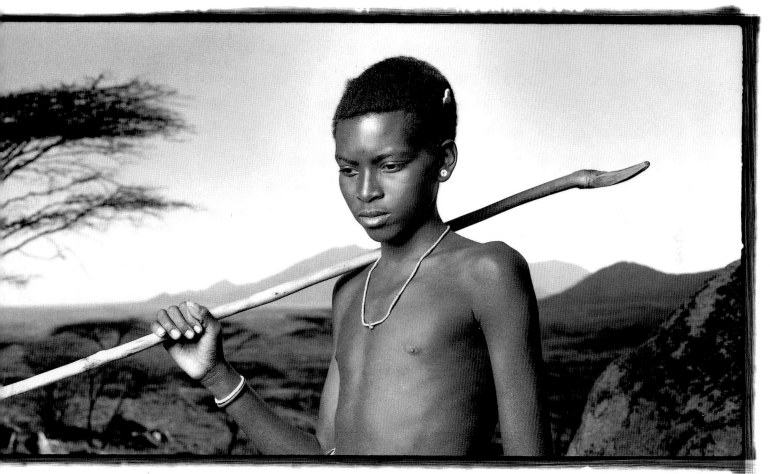

Sayuloi 12

SAYULOI 12, MT. NYIRU, KENYA As the eldest son in a family of five, Sayuloi has the responsibility of helping his father tend the family's cattle and goats. Even though he would like to attend the school that has just opened in his territory, Sayuloi's familial obligations won't allow it. Within four years, he will become initiated as a *moran* (warrior) and assume the responsibility for the livestock. *Samburu Tribe*

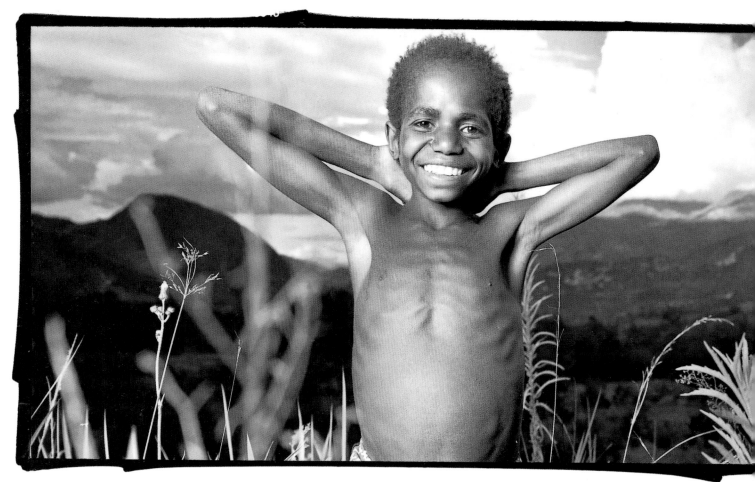

Noragara, Irian Jaya

DAPAN 9, NORAGARU, IRIAN JAYA (INDONESIA) Dapan, the youngest of three brothers, had just begun school. Of his family's $240 annual income, $43 will be spent on his education. His parents also support the older brothers' schooling. I asked his father why they make this sacrifice, since the few jobs available are given to Indonesians from other islands instead of to the native Papuans. He replied, "We're hoping things will change." *Loni Tribe*

Dapan 9

43

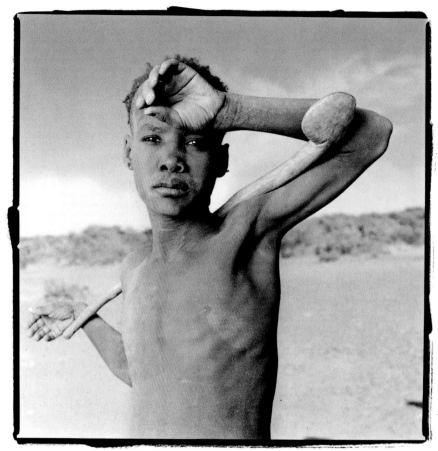

Omorate, Ethiopia *Naye 9*

NAYE 9, OMORATE, ETHIOPIA Naye's family lives near Ethiopia's Lower Omo River. When I went to the river to get some water, Naye followed me there. Grabbing my arm protectively, he pointed out a crocodile, then took my pail and filled it for me in the muddy river. He then walked over to a bush, broke off a branch, and used it to stir the dark brown liquid. Within seconds, the mud settled, leaving crystal clear water. *Galeb Tribe*

44

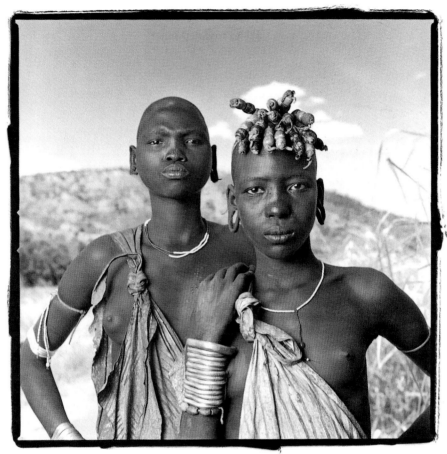

Mago National Park, Ethiopia

Odumo 16
Otino 18

ODUMO 16, OTINO 18, MAGO NATIONAL PARK, ETHIOPIA Odumo and Otino are cousins who were grazing their cattle when I met them. Even though the Mursi have lived in this area for decades, the recently created Mago National Park has placed restrictions on cattle movement. Resentment over these restrictions, combined with the Mursis' recent acquisition of AK-47s, had led to the deaths of three park rangers in the last four months. *Mursi Tribe*

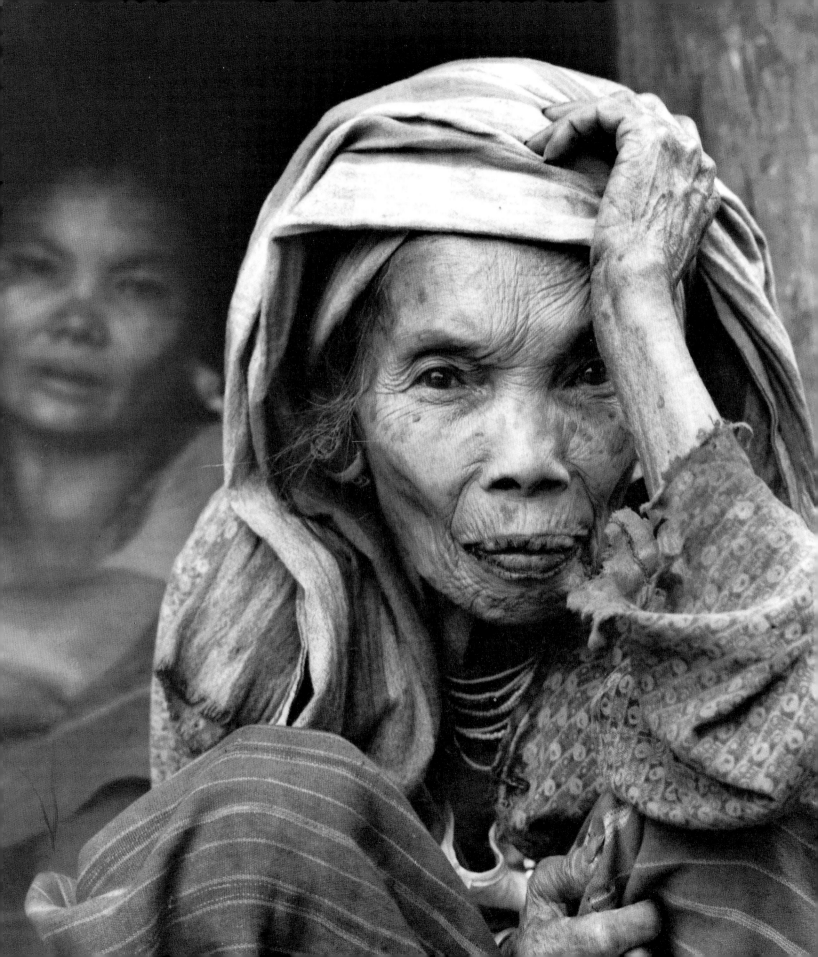

PAO 78, SAPPONG, THAILAND Pao has lived in Thailand for nearly 25 years as a refugee from the civil war in Burma. She lost her husband in the fighting as she fled her homeland. Many people in her new village have resorted to growing opium poppies in order to survive. She invited me into her one-room bamboo hut and graciously offered me a plate of very large fried beetles. I cautiously nibbled on one beetle, then enjoyed many more. *Karen Tribe*

47

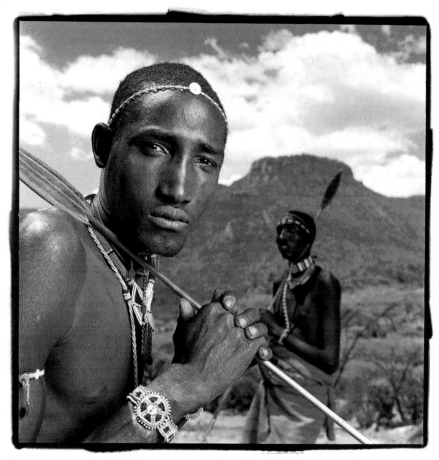

Mt. Nyiru, Kenya *Loboin 24*

LOBOIN 24, MT. NYIRU, KENYA Shortly after he turned 16, Loboin became a *moran,* or warrior. His transformation from boyhood began
with a grueling 40-day walk across the perilous Chalbi Desert and ended with his circumcision ceremony.
Loboin is now entrusted with guarding and caring for his family's only means of survival—one camel, 11 cattle, and 19 goats. *Samburu Tribe*

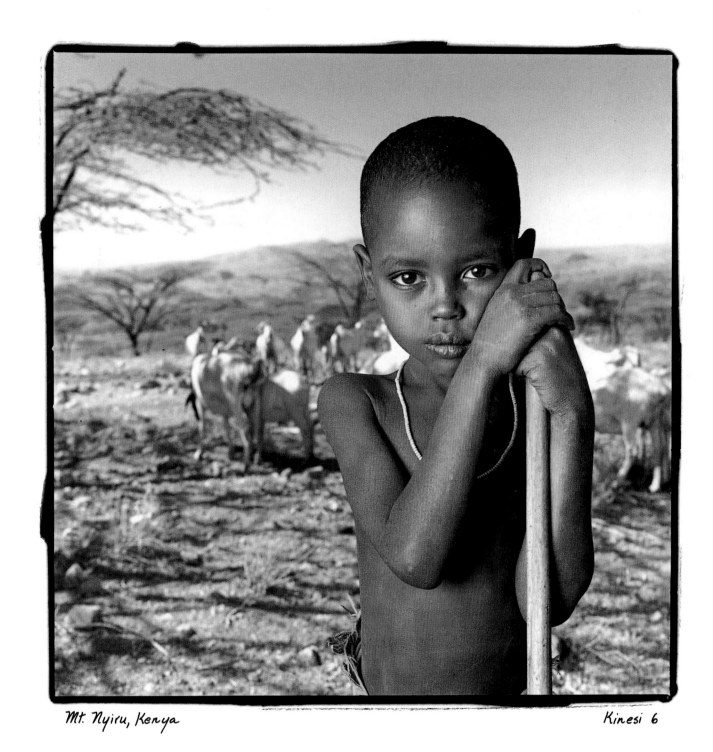

Mt. Nyiru, Kenya Kinesi 6

KINESI 6, MT. NYIRU, KENYA Kinesi often helps his older brother take care of the family goats. He is the only one of seven children who was selected by his parents to attend school. Since his family is seminomadic, sometimes he must walk alone
nearly four hours—over terrain populated by baboons and leopards—to get to the only school in his district. His mother says that Kenesi runs most
of the way—not from fear of predators but from the excitement of school. *Samburu Tribe*

49

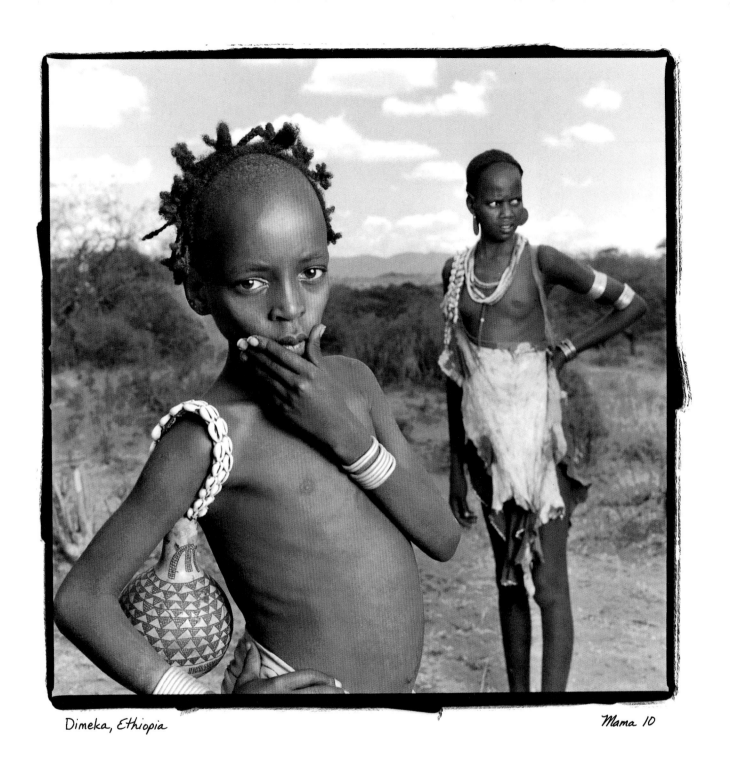

Dimeka, Ethiopia

Mama 10

MAMA 10, DIMEKA, ETHIOPIA Mama was on her way to the Dimeka market to sell the honey she had collected over the past week. Last year, her father died of tuberculosis, leaving her mother alone to care for the children. Hamar custom does not allow a widow to remarry, so the children will be expected to carry the extra workload. When I gave her a Polaroid of herself, Mama stared at it for several minutes in disbelief. She didn't think it was really her. *Hamar Tribe*

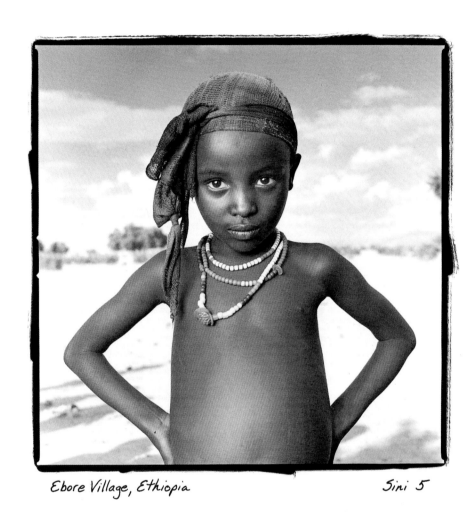

Ebore Village, Ethiopia *Sini 5*

SINI 5, EBORE VILLAGE, ETHIOPIA Sini had spent the morning working with her brother in their community sorghum field. When I set up my equipment to take her photo, a small crowd gathered. After I had taken a few shots, suddenly everyone leaped up and bolted from the scene, leaving me standing there alone and wondering what had happened. I later learned that a warrior from the neighboring Hamar tribe had been seen entering their territory. *Ebore Tribe*

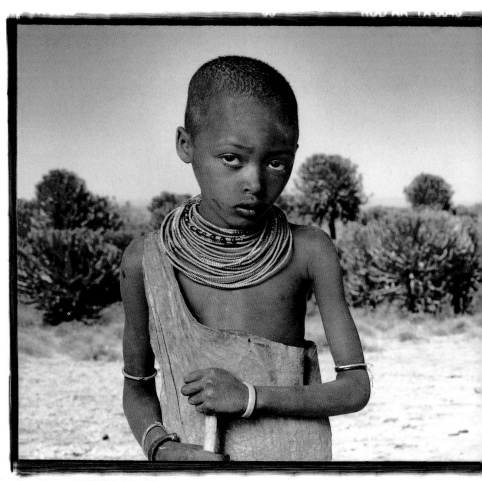

Ndoto Range, Kenya

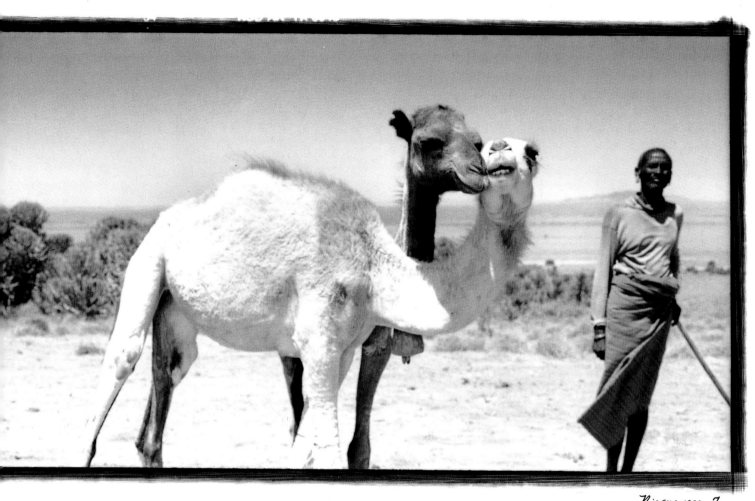

Njasunyers 7

NJASUNYERS 7, NDOTO RANGE, KENYA Njasunyers had just walked 12 miles with her camels to get water at one of the few wells in her territory. The well, 5 feet in diameter and 60 feet deep, requires nine people standing inside on ledges—one above the other—to pass the water up to the surface. Although only 7 years old, Njasunyers makes the journey three times a week, carrying water back to her family in several one-gallon gourds. *Samburu Tribe*

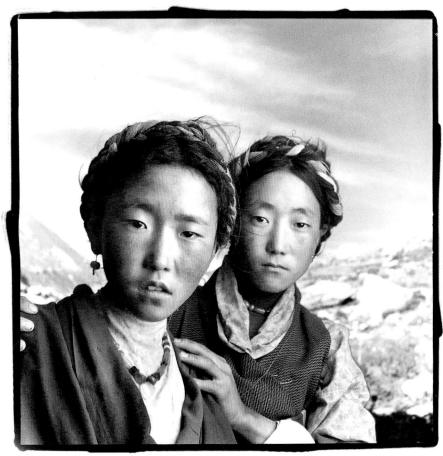

Nyalam, Tibet

Shelo 20
Benba 17

SHELO 20, BENBA 17, NYALAM, TIBET Shelo and Benba, best friends since childhood, are currently working as hostel maids in Nyalam, an old Tibetan village that has recently become a stopover for climbers on their way to Mt. Everest. As Tibetans, they are rapidly becoming an insignificant minority in their own country, due to the massive influx of Chinese into Tibet.

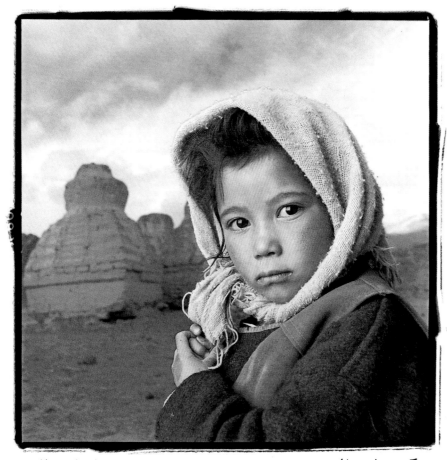

Shey, Ladakh *Yangchan 5*

YANGCHAN 5, SHEY, LADAKH (INDIA) Yangchan was on her way to the temple, or *gompa,* with her mother and her sister
to make an offering when I first met them. The Shey *gompa* houses the largest Buddha statue in Ladakh, the most remote state in India. Known as
"Little Tibet," Ladakh is actually more Tibetan than Tibet itself, since its population has not been subjected to the repressive domination
of the Chinese government. *Tibetan*

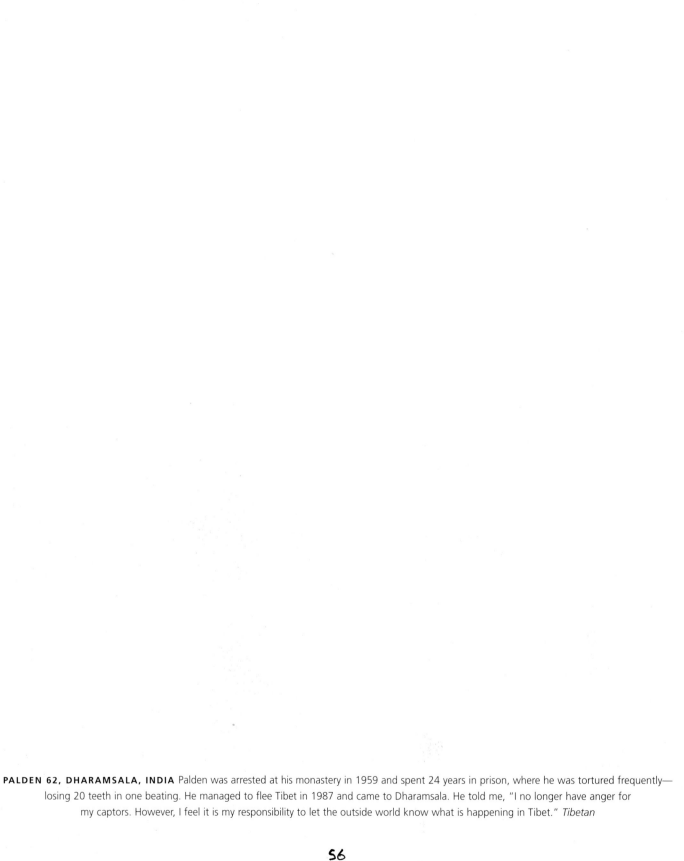

PALDEN 62, DHARAMSALA, INDIA Palden was arrested at his monastery in 1959 and spent 24 years in prison, where he was tortured frequently—losing 20 teeth in one beating. He managed to flee Tibet in 1987 and came to Dharamsala. He told me, "I no longer have anger for my captors. However, I feel it is my responsibility to let the outside world know what is happening in Tibet." *Tibetan*

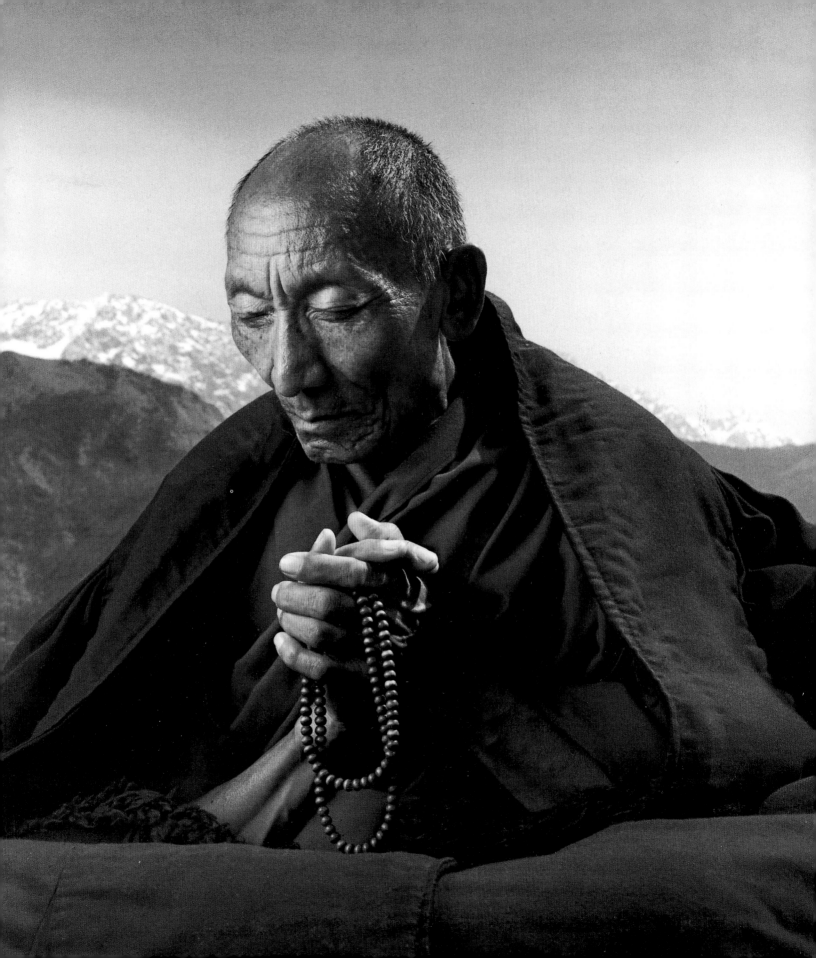

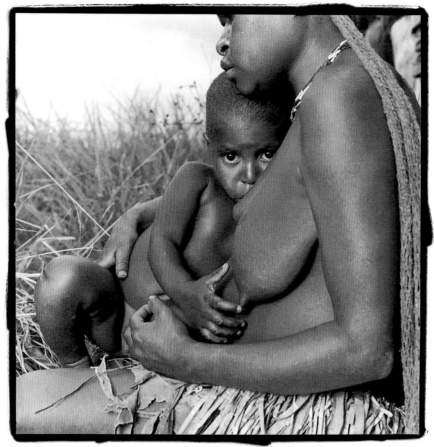

Kokuban, Irian Jaya

Ekeba 18
Erak 18 mos.

EKEBA 18, ERAK 18 MONTHS, KOKUBAN, IRIAN JAYA (INDONESIA) Ekeba had walked two days over very rough terrain to trade her sweet potatoes for candles and matches at the Wemena market. She is the fourth and youngest wife of her relatively wealthy husband—he owns 25 pigs. Like most Yale women, she spends 12 to 14 hours a day cooking, collecting firewood, and working the garden. *Yale Tribe*

58

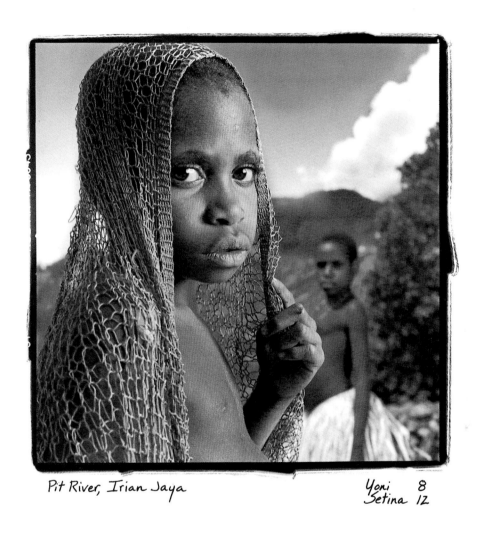

Pit River, Irian Jaya

Yoni 8
Setina 12

YONI 8, SETINA 12, PIT RIVER, IRIAN JAYA (INDONESIA) Yoni and her cousin Setina spend most of their day farming the family sweet-potato garden. Although a school built by the Indonesian government has just opened in their village, they have no plans to attend. Tuition is very expensive for them, and it is well known that even if they graduate, because of discrimination the few jobs available in Irian Jaya will be given to Indonesians from other islands instead of indigenous people like themselves. *Loni Tribe*

Mt. Nyiru, Kenya

SUKULEN 37, MT. NYIRU, KENYA As a young girl, Sukulen began having dizzy spells and hearing voices. She said she was very frightened and thought she was getting ill. Her grandmother assured her that she was healthy and was, in fact, very gifted. Sukulen is now a highly respected "predictor" in her tribe. Two months before I arrived, she had told several people in her village that I was coming and had described in detail my appearance and the equipment I was using. *Samburu Tribe*

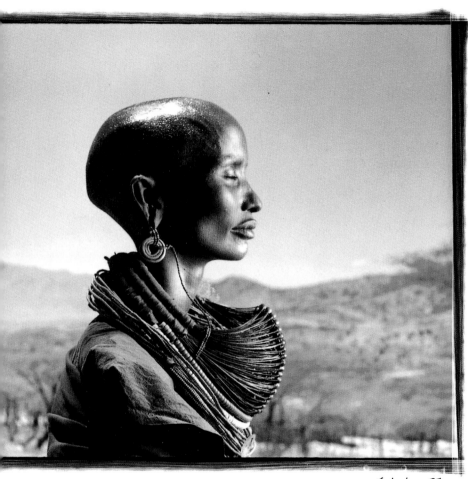

Sukulen 37

61

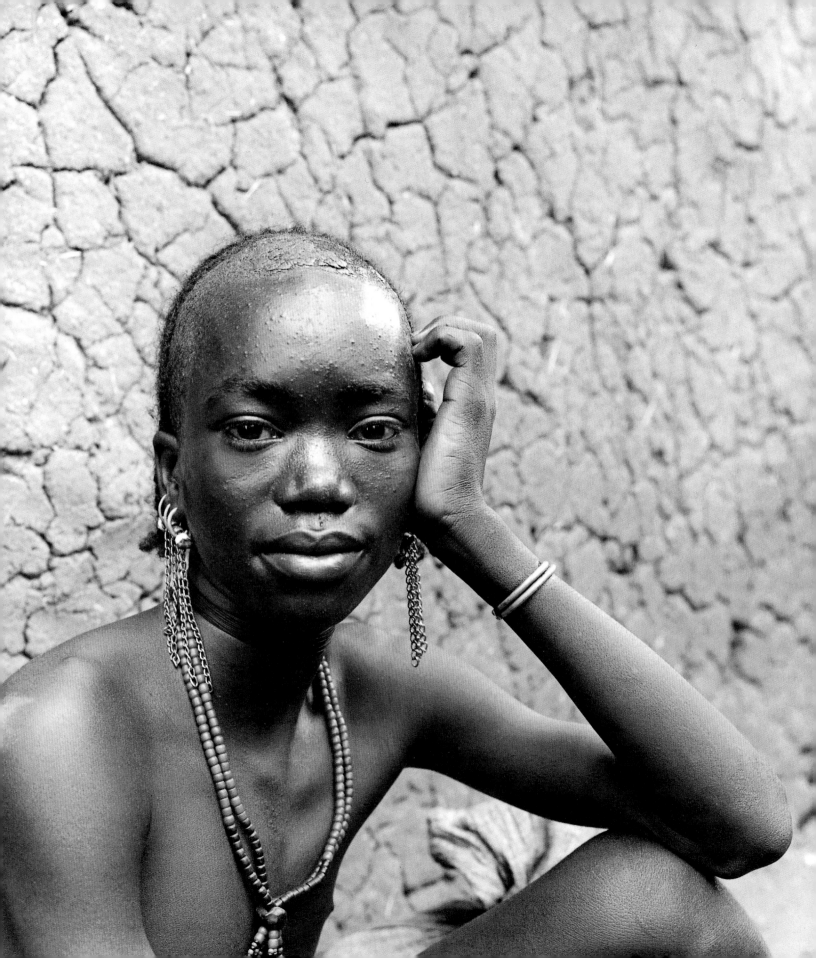

SILBO 17, DIMEKA, ETHIOPIA Silbo had spent the day at the market inviting friends to his *bullah,* a ceremony initiating him into warriorhood, which would take place in three weeks. Before the ceremony, female guests will beg to be whipped by young warriors to show their support for Silbo's initiation. Silbo must run across the backs of 30 bulls four times. If he falls, he himself will be whipped, as will his mother for not feeding him properly. *Hamar Tribe*

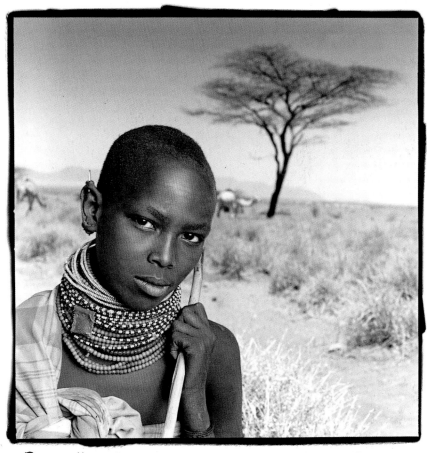

Baragoi, Kenya Lothuru 12

LOTHURU 12, BARAGOI, KENYA Lothuru, a nomad, was grazing her camels when I met her outside the village of Baragoi. Although she is only 12, her marriage has already been arranged by her parents and will take place within a year. She told me that she has no doubt that her parents will make the right choice for her. Since circumcision is not a Turkana practice, Lothuru will not be circumcised prior to her marriage. *Turkana Tribe*

64

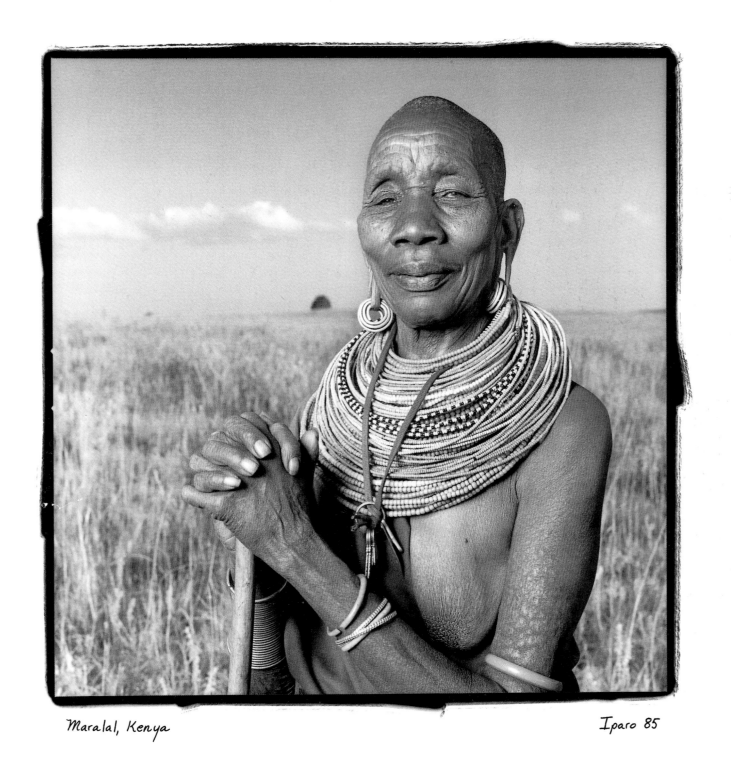

Maralal, Kenya

Iparo 85

IPARO 85, MARALAL, KENYA The earrings that Iparo wears indicate that all 12 of her children—boys and girls—have completed their circumcision ceremonies. Her last child was born when she was 61. A recent widow, she had just been forced to leave her home because of violent cattle raids between the tribes in her territory. The raids have become deadly because of drought and the introduction of AK-47s into the area. *Samburu Tribe*

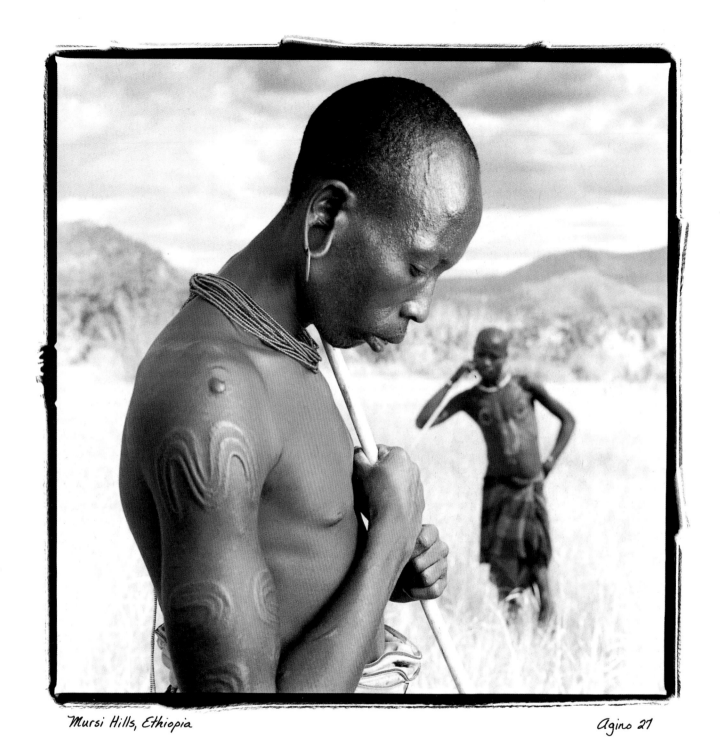

Mursi Hills, Ethiopia

Agino 27

AGINO 27, MURSI HILLS, ETHIOPIA Agino, a Mursi warrior, was adamant about wanting a Polaroid of himself. However, when I pointed the camera at him, he immediately looked down. I later learned the Mursi believe that looking directly into the lens can cause blindness. Although unauthorized fighting within the Mursi tribe is a taboo, warriors who kill an enemy are accorded great status. Each curved scar on Agino's arm represents an enemy killed. *Mursi Tribe*

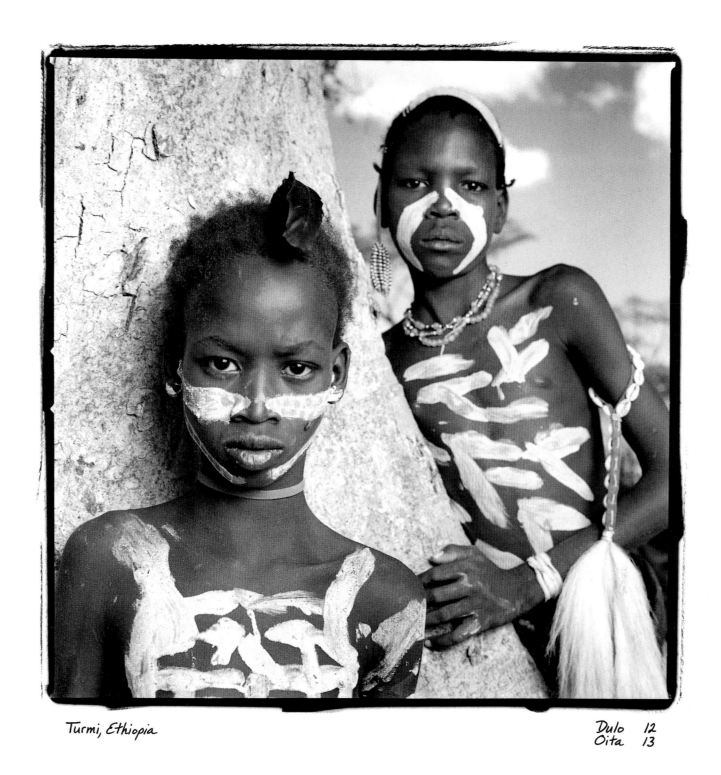

Turmi, Ethiopia

Dulo 12
Oita 13

DULO 12, OITA 13, TURMI, ETHIOPIA Dulo and Oita were on their way to a *bullah* ceremony—a rite of passage in which a male initiate must run naked four times across the backs of 30 bulls. The boys were to help steady the bulls during the ceremony. After I paid them for allowing me to take their photograph, Dulo and Oita immediately divided the money among themselves and the tribespeople around them. I've witnessed this generous practice among many different tribal groups. *Hamar Tribe*

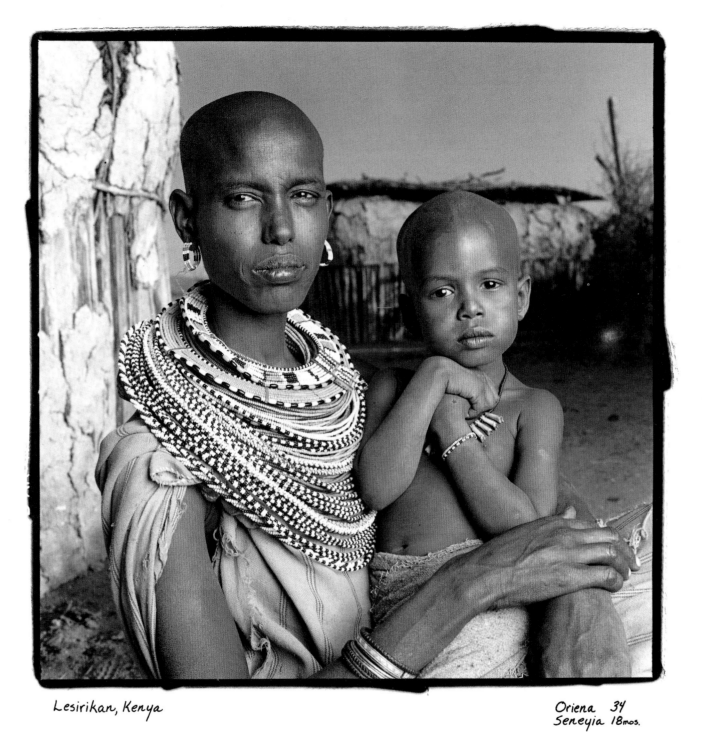

Lesirikan, Kenya

Oriena 34
Seneyia 18mos.

ORIENA 34, SENEYIA 18 MONTHS, LESIRIKAN, KENYA In the Samburu culture, females are circumcised two days before their weddings. Oriena assists the circumciser in her village. They had been working with a government nurse, who provided antibiotics during the procedure and encouraged minimal tissue removal. Recently, however, because of the blanket condemnation of the practice by the developed world, funding for these nurse/educators has been terminated and infection rates have shot back up. *Samburu Tribe*

Mpoori Village, Kenya *Leleur 60*

LELEUR 60, MPOORI VILLAGE, KENYA Once owning almost 200 cattle, Leleur was considered wealthy. He had raised three sons and six daughters with two wives. Two months before this photograph was taken, however, he had lost all his cattle in a raid. Stealing a few cattle has always been a tolerated game between warriors of competing tribes. However, as the drought has progressed, the raids have grown much more dangerous, with the AK-47 replacing the spear as the weapon of choice. *Samburu Tribe*

Maralal, Kenya

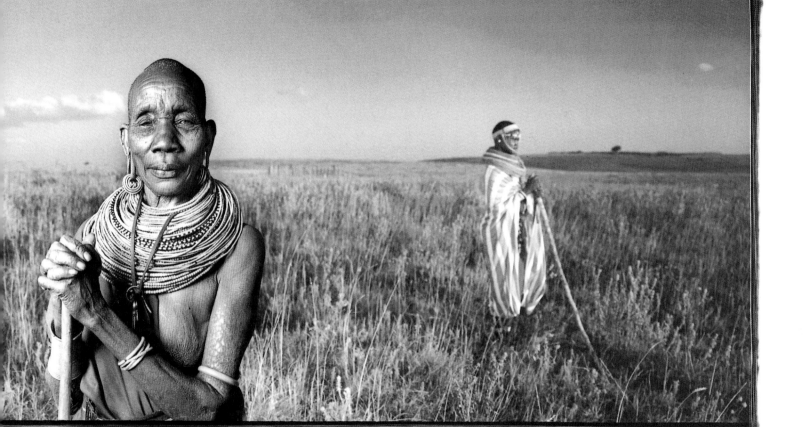

Iparo 85
Sambait 15

IPARO 85, SAMBAIT 15, MARALAL, KENYA Sambait has lived with Iparo since she was 3 years old. She is one of several "foster" children Iparo has helped raise while rearing her own 12 biological children. When I asked the family what had happened to Sambait's parents, they said, "Nothing." Raising children among the Samburu is considered a communal activity. Children don't "belong" to their parents in the Western sense. There was just a natural attraction between Sambait and Iparo, and that led to the relationship. *Samburu Tribe*

71

ECHUKA 24, ERAGAI 21, BARAGOI, KENYA Echuka and Eragai are good friends who had spent all day walking in 110-degree heat to the market in Baragoi to get salt for their camels and goats. They called me "the fish" because of the quantity of water I was drinking. They apparently didn't need to drink at all. The four cowry shells on Eragai's head indicate that she has had a miscarriage. She will wear the shells for the rest of her life. *Turkana Tribe*

72

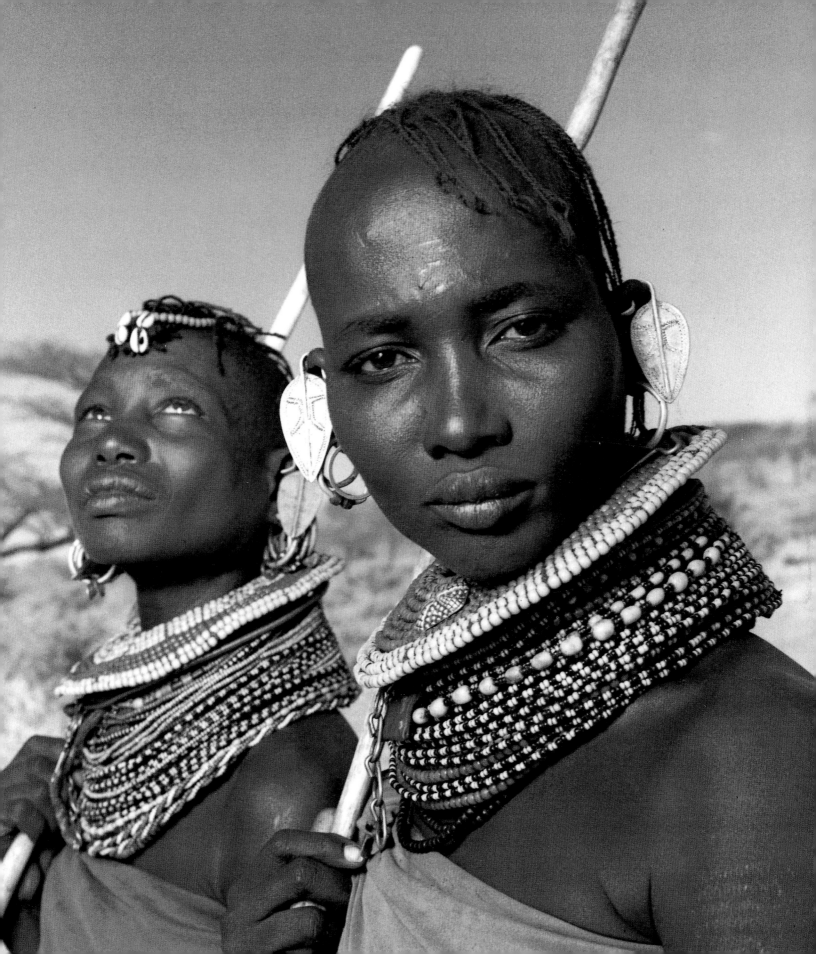

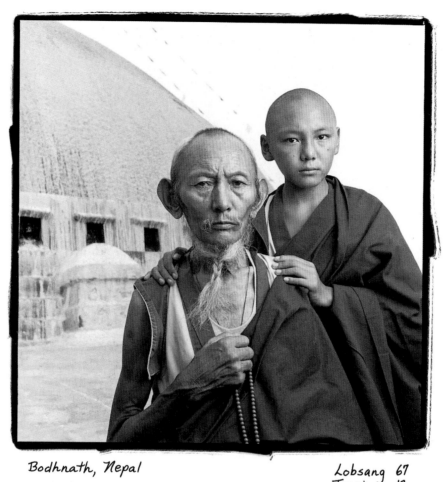

Bodhnath, Nepal

Lobsang 67
Tensin 13

LOBSANG 67, TENSIN 13, BODHNATH, NEPAL Lobsang and 66 fellow monks were imprisoned in 1959. Released 21 years later, he was one of only three survivors. While he was in prison, his best friend—a *rinpoche* (a high lama)—died in his arms. Tensin was later discovered to be the reincarnation of that friend. Lobsang said there are many characteristics of his old friend in the young boy. *Tibetan*

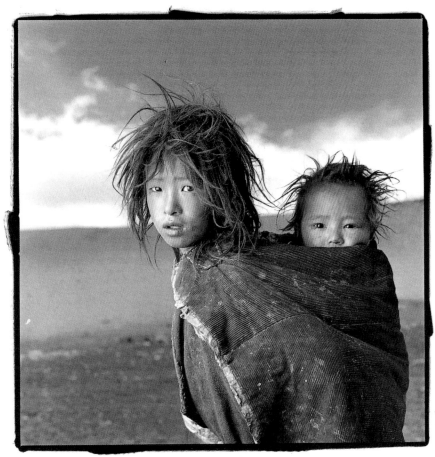

Ladakh, India

Jigme 8
Sonam 18mos.

JIGME 8, SONAM 18 MONTHS, LADAKH, INDIA Jigme and Sonam are sisters whose nomadic family had just come down from the Himalayan highlands to their 16,500-foot winter camp on the Tibetan Plateau. When I gave Jigme a Polaroid of herself, she looked at it, squealed, and ran into her tent. I assumed that this was one of the only times she had seen herself, since her family did not own a mirror. *Tibetan*

Tana Toraja, Indonesia

Aldo 10
Erpi 7
Rosie 7

ALDO 10, ERPI 7, ROSIE 7, TANA TORAJA, INDONESIA Aldo and his friends had just spent the morning washing two of his family's water buffalo in the river. When he turned 8, Aldo was given the responsibility of tending the two buffalo. Valued at close to $800 each, they represent more than one-third of his parents' wealth. They will both be slaughtered at his uncle's funeral in two months. The funeral is being delayed until the last rice-harvest ceremony is completed, so as not to mix the rites of life with those of death. *Torajan*

Huejuquilla El Alto, Mexico

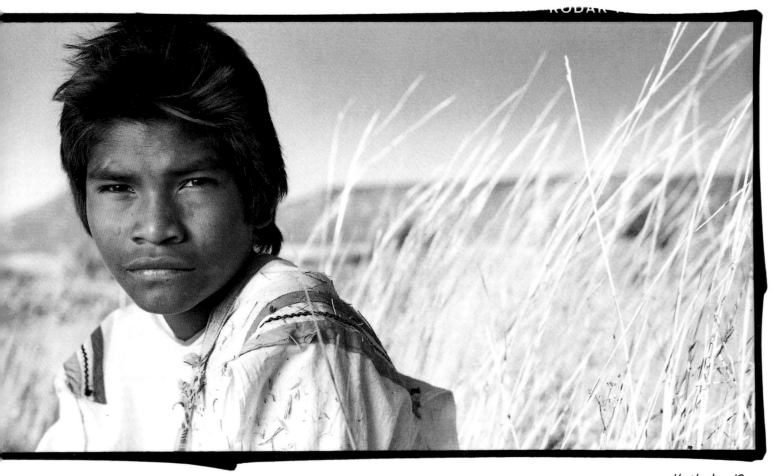

Heriberto 13

HERIBERTO 13, HUEJUQUILLA EL ALTO, MEXICO More than half of all Huichol undertake the rigorous studies needed to become a shaman. Heriberto now spends much of his time as an apprentice, learning the intricate beadwork used in making prayer bowls. He will learn how to tap into the metaphysical world and use it as a reservoir from which he can envision and create designs. He uses art as a means to connect with the forces underlying our world. *Huichol*

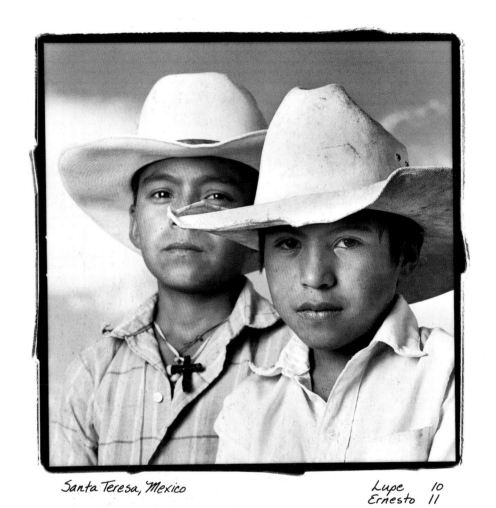

Santa Teresa, Mexico

Lupe 10
Ernesto 11

LUPE 10, ERNESTO 11, SANTA TERESA, MEXICO Lupe and Ernesto, mestizos of mixed Huichol and Spanish ancestry,
are close friends who live in a remote village in the Sierra Madre mountains of Mexico. Five years ago, Lupe's older brother Daniel left their village to
work in the vineyards of Northern California. A well-worn photo of Daniel next to his new Pontiac Trans Am has inspired Lupe to make plans
to follow in his brother's footsteps. *Huichol*

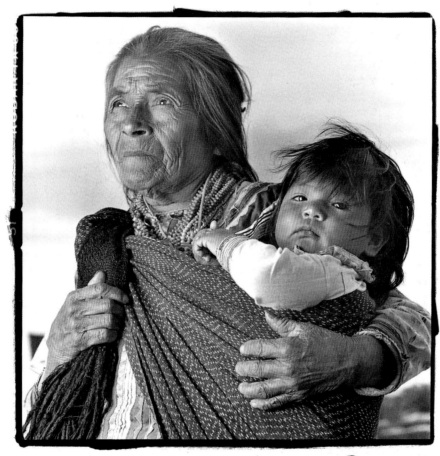

Santa Teresa, Mexico

Dimicia 68
Sinchi 14mos.

DIMICIA 68, SINCHI 14 MONTHS, SANTA TERESA, MEXICO Sinchi is Dimicia's great-granddaughter. In a few days, Sinchi and her parents will leave on a 75-mile pilgrimage to a sacred location in the rugged Sierra Madre mountains to hunt for *hikuri,* the small peyote cactus. Although Dimicia will stay at home while Sinchi's parents search for *hikuri,* all three will take peyote and—using a type of intuitive telepathy— share in the pilgrimage and ceremonies. *Huichol*

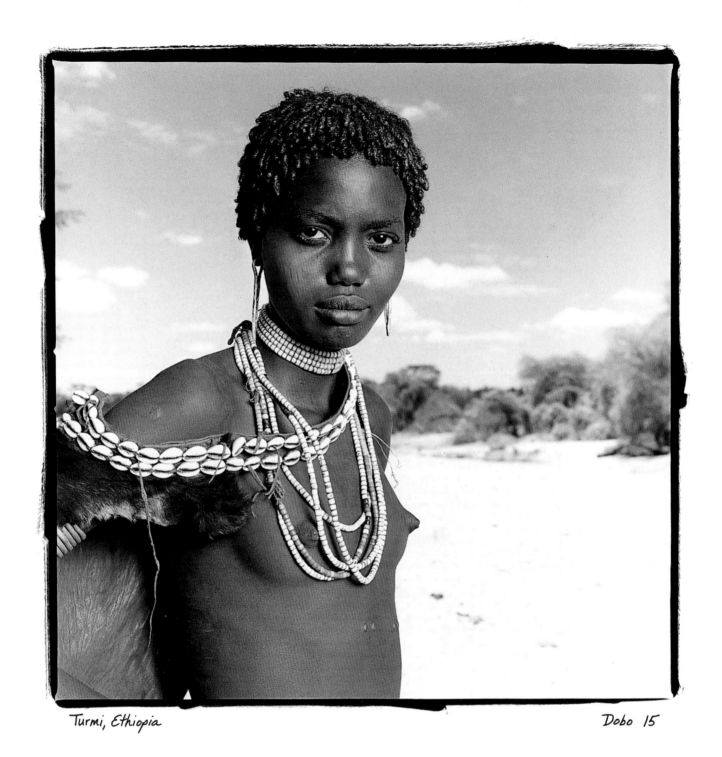

Turmi, Ethiopia

Dobo 15

DOBO 15, TURMI, ETHIOPIA I saw Dobo in the market selling firewood and asked my interpreter, a young Hamar boy, to let her know that I wanted to photograph her. He looked at me like I was crazy and said, "She is ugly—too thin and tall."
I told him I thought she was beautiful. He looked at me quizzically, then slowly asked her. The next day, he asked me if he should marry Dobo.
I laughed and asked, "Are you serious?" He said he was. *Hamar Tribe*

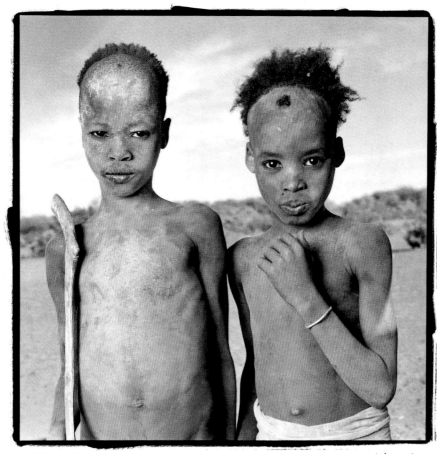

Omorate, Ethiopia

Lutdai 7
Kolle 6

LUTDAI 7, KOLLE 6, OMORATE, ETHIOPIA Lutdai and Kolle belong to the Galeb tribe, who inhabit an extremely dry and desolate area of southwest Ethiopia. For weeks at a time, the wind begins to blow early in the day, creating dust storms that last until the sun goes down. Shortly after I took this photo one morning, the wind—like clockwork—began to kick up a blinding haze. The boys went about their play as if nothing had changed. *Galeb Tribe*

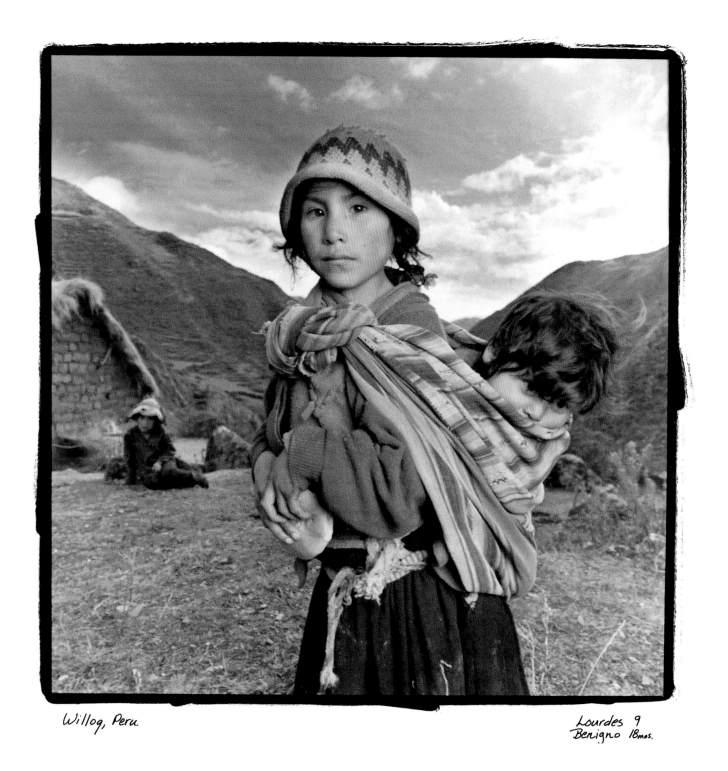

Willoq, Peru

Lourdes 9
Benigno 18mos.

LOURDES 9, BENIGNO 18 MONTHS, WILLOQ, PERU Lourdes gets up at five o'clock in the morning to take her cows up the mountain before school begins. After school, she makes the three-mile trek back up the mountain to retrieve the cows and returns home to help her mother cook dinner. She carries her sister Benigno with her most of the day. At school, she currently speaks Quechua, her native language, but next year she will be taught in Spanish. *Quechua*

Ollantaytambo, Peru Vicentina 15mos.

VICENTINA 15 MONTHS, OLLANTAYTAMBO, PERU Vicentina's father met her mother three years ago while selling firewood at a market several miles from his village. Once Vicentina was conceived, the couple built a home in the mountains and moved in together.
It is not the custom of the Quechua for couples to marry; however, they remain monogamous. Like most Quechua mothers, Vicentina's will breast-feed her until she is almost 3 years old as a method of contraception. *Quechua*

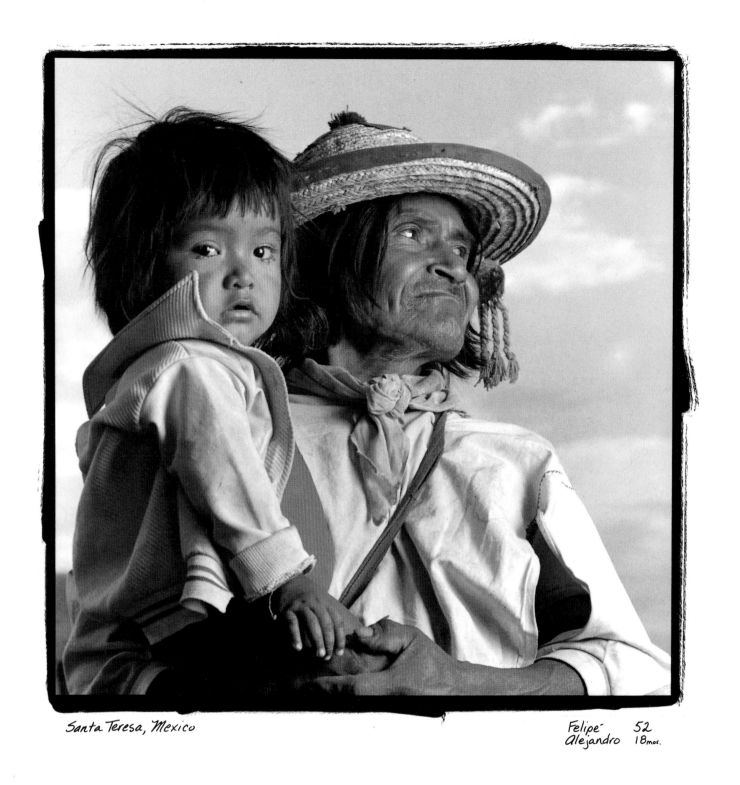

Santa Teresa, Mexico

Felipé 52
Alejandro 18 mos.

FELIPÉ 52, ALEJANDRO 18 MONTHS, SANTA TERESA, MEXICO Felipe had just taken his pregnant wife to the small clinic in Santa Teresa to find help for her severe cramps. Like many Huichol, they had left their homeland in the mountains to work in the tobacco fields near the coast. Because of the high use of pesticides in the fields, miscarriages as well as cancer are common among Huichol migrant workers. Children like Alejandro typically accompany their parents while they labor in the fields. *Huichol*

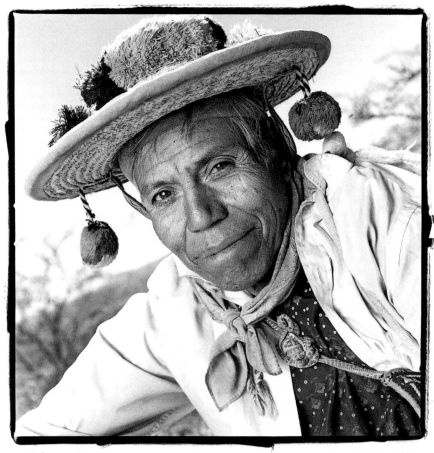

Mesquitec, Mexico

Guadalupe 69

GUADALUPE 69, MESQUITEC, MEXICO I was told that Guadalupe was a well-known and highly respected Huichol shaman. He shared with me some details of his long and arduous apprenticeship. Over several decades, there were frequent fasts, solitary meditation in the mountains, periods of sexual abstinence, and numerous pilgrimages to distant, sacred places. So many of the Huichol take part in the apprenticeship that they are referred to as a tribe of shamans. *Huichol*

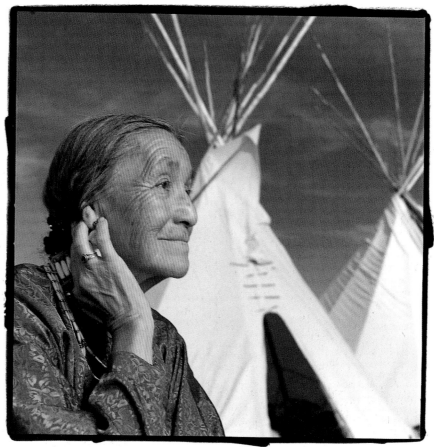

Rocky Boy, Montana *Lucille Windy-Boy 71*

LUCILLE WINDY-BOY 71, ROCKY BOY, MONTANA (UNITED STATES) Lucille, a recent widow, is well known around Rocky Boy for the high-quality tepees she sews. Her husband had been known throughout the territory as an important spiritual leader. When I met Lucille, she was surrounded by some of her 42 grandchildren and 32 great-grandchildren. They proudly told me that Lucille and her husband had started college five years ago and earned their bachelor degrees together. *Chippewa-Cree tribes*

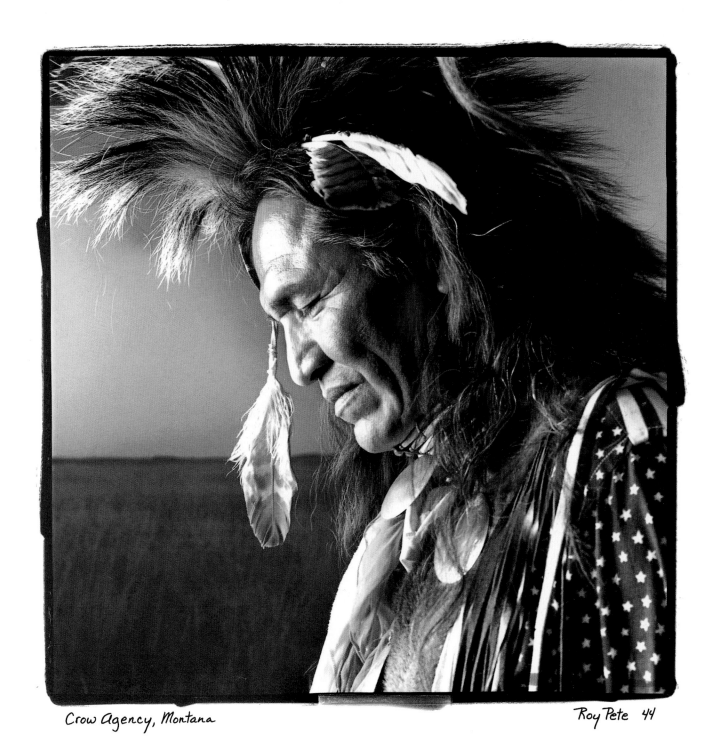

Crow Agency, Montana

Roy Pete 44

ROY PETE 44, CROW AGENCY, MONTANA (UNITED STATES) When he was a child, Roy Pete had "visions of my people coming home."
Having attended powwows now for 20 years, he says many feelings come up while one is dancing in the ceremonial circle.
"You come to an understanding that you are part of a much larger process and very connected to it," he told me. "It is such a feeling of returning."
Roy works as a software engineer in Wyoming. *Navajo Tribe*

Settlement Camp #1, Ladakh

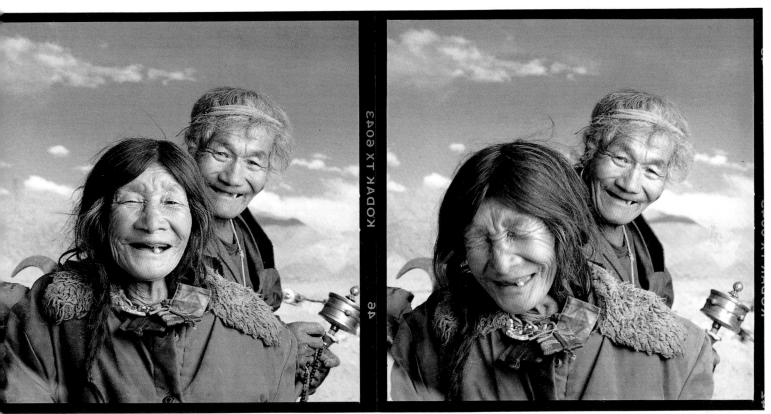

Botok 76
Tsangpa 78

BOTOK 76, TSANGPA 78, SETTLEMENT CAMP #1, LADAKH, INDIA Botok and Tsangpa were classified as wealthy by the Communist authorities in 1962, because they owned almost 1,000 sheep and goats. Threatened with imprisonment, they fled across the border into the Indian state of Ladakh with their three daughters and Tsangpa's other husband—it is not uncommon for Tibetan women to take more than one. *Tibetan*

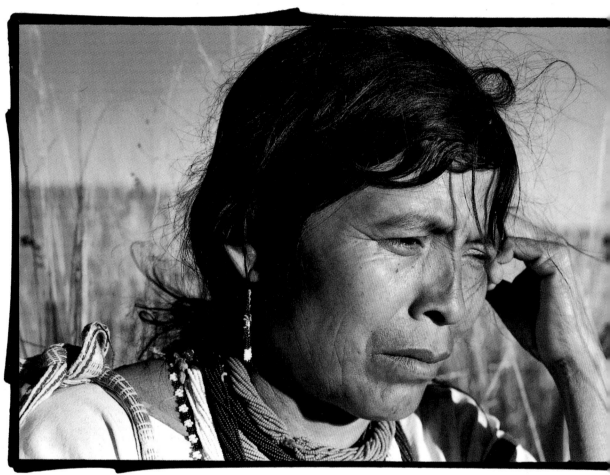

Huejuquilla El Alto, Mexico

MICHELLA 46, ROBERTO 48, HUEJUQUILLA EL ALTO, MEXICO Michella and Roberto had just made their regular monthly trip to Huejuquilla to bring their artwork to the Huichol Center for Cultural Survival. The Center, which was established by an American anthropologist, encourages the Huichol to work as artists, rather than as migrant tobacco field-workers, by supplying them with beads and marketing their work. Michella still suffers from headaches caused by years of exposure to pesticides in the tobacco fields. *Huichol*

Michella 46
Roberto 48

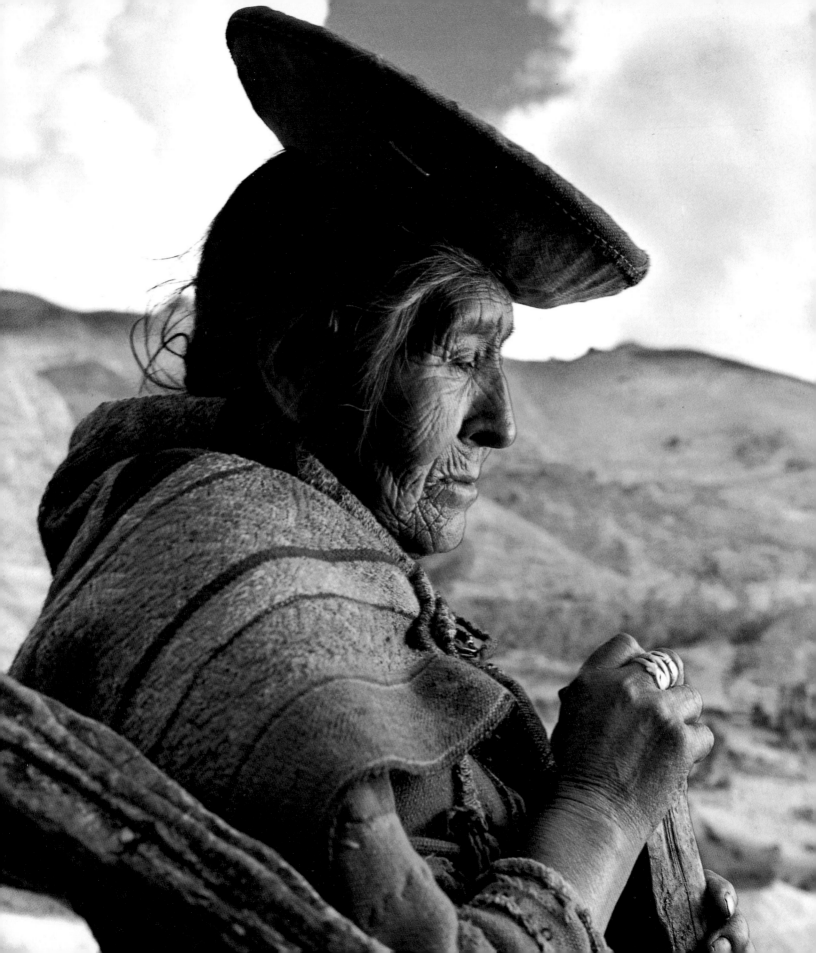

CIRILA, OLLANTAYTAMBO, PERU Cirila was sorting seed potatoes with her grandchildren when we met. Although she doesn't remember her age, she knows she was born in a potato field during the sowing season. She has cooked for her children and their families since the death of her husband 20 years ago. When I asked her about the hatchet hanging from her belt, she said that she uses it to collect firewood for family meals. *Quechua*

95

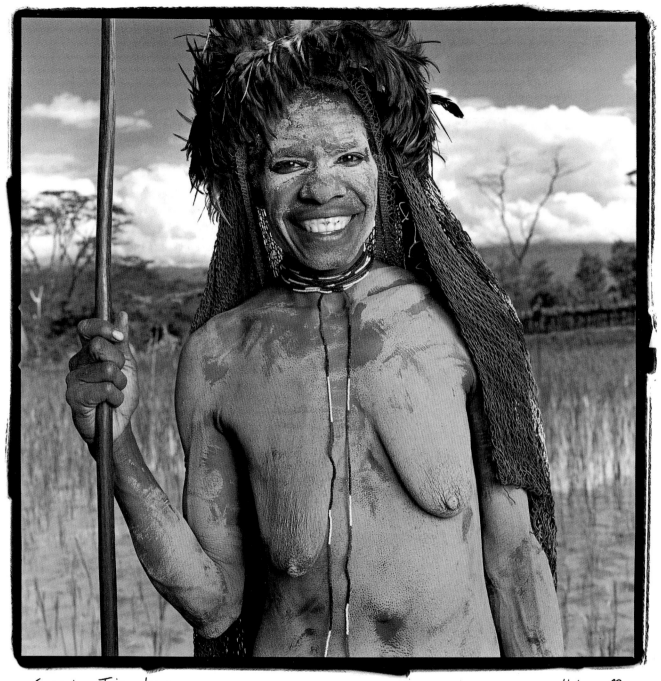

Sumpaima, Irian Jaya

Helena 29

HELENA 29 SUMPAIMA, IRIAN JAYA (INDONESIA) Helena's younger sister died two years ago from a snakebite. As a consequence, Helena will cover her own body with mud two days a month for the rest of her life. This practice not only honors the deceased, but also assures the living that their relatives' spirits will not get angry with them. When I expressed surprise that she would continue this practice forever, Helena reminded me that spirits are no different from us—they like to be remembered. *Dani Tribe*

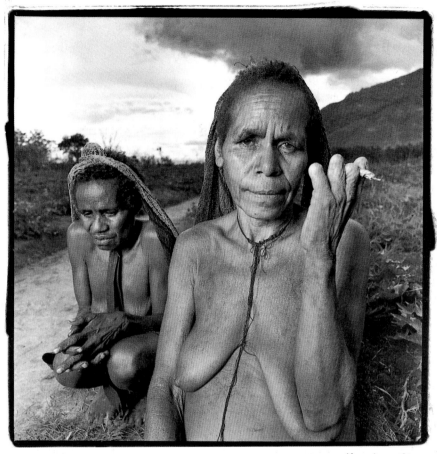

Jiwika, Irian Jaya

Horek 43
Enalia 50

HOREK 43, ENALIA 50, JIWIKA, IRIAN JAYA (INDONESIA) Horek typically spends all day working in the garden and at dusk returns home to
cook and help care for her new granddaughter. Like most women her age, she traditionally cuts a finger off each time
a relative or a close friend dies. Paying respect to and caring for one's spirit ancestors is considered essential for the health of the tribe. Over the years,
she has lost two brothers, a daughter, and a husband to malaria. *Dani Tribe*

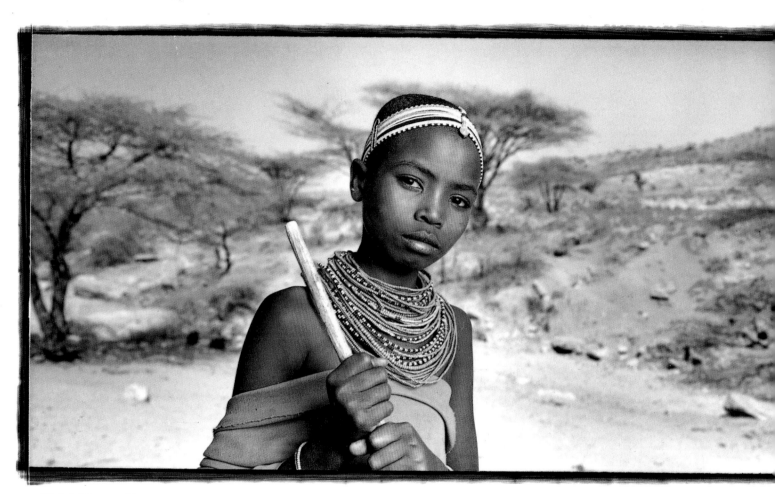

Ndoto Range, Kenya

Lekarate 9

LEKARATE 9, NDOTO RANGE, KENYA In a year or two, Lekarate will be ready to become the companion of a young *moran,* or warrior. Her parents will build a hut for the couple where they will eat and sleep together. Even though they will become very close during this four- to five-year relationship, sex is strictly forbidden. When their domestic trial comes to an end, Lekarate's father will probably select a much older man for her to marry. *Samburu Tribe*

99

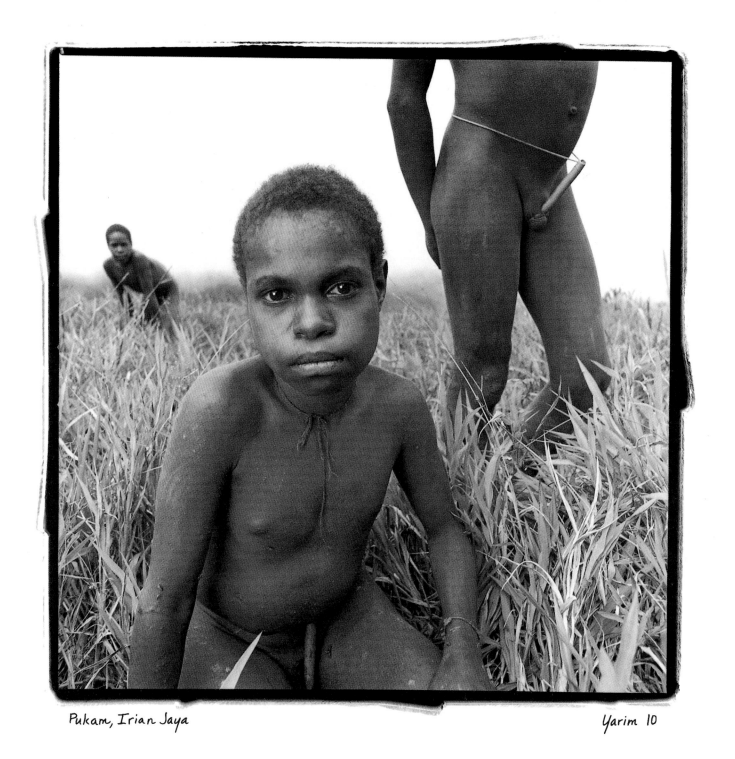

Pukam, Irian Jaya

Yarim 10

YARIM 10, PUKAM, IRIAN JAYA (INDONESIA) When I first saw them, Yarim and his friends were playing a form of soccer
with a ball made from woven palm leaves. They had spent the morning hunting birds in the forest with bows and arrows and were just about to
start class in their little Indonesian government school. Boys from the Dani tribe start wearing penis gourds at about age 6 as a sign
of modesty. *Dani Tribe*

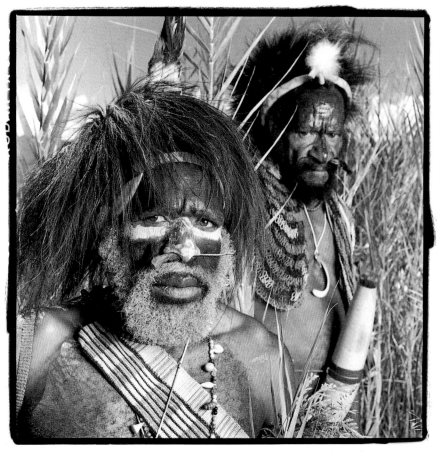

Pit River, Irian Jaya Epius 27
 Wele 45

EPIUS 27, WELE 45, PIT RIVER, IRIAN JAYA (INDONESIA) Epius and Wele put on their warrior attire when they saw me taking photographs and handing out Polaroids. Normally, they dress up only for celebrations or to fight. Epius is from a village in Illaga, which is several days' walk away. He had come to Pit River for an education and had just graduated from high school. Since no jobs are available, he plans to return to his village to help settle a conflict with a neighboring tribe. *Loni Tribe*

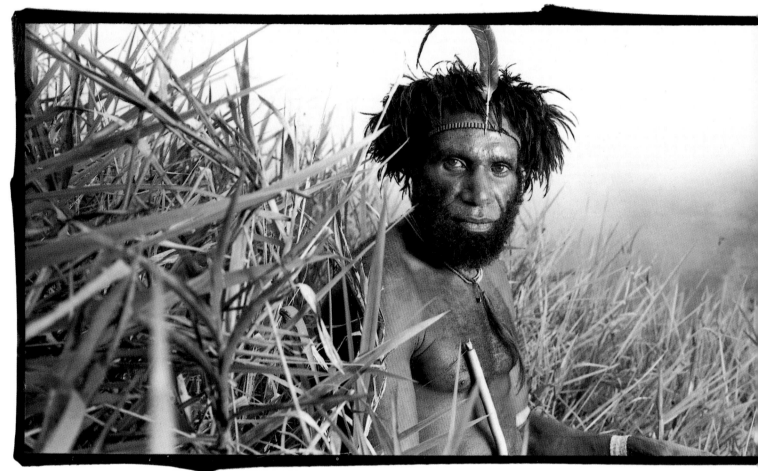

Wesagalep, Irian Jaya

ELIAS, WESAGALEP, IRIAN JAYA (INDONESIA) Elias is considered the strongest warrior in his village.
Although most of the ritualistic battles among the tribes have stopped, his tribe still fights over the right to pick coconuts in the jungle. Elias has
numerous scars on his body from spear and arrow wounds. When I first met him, he was out searching for a center pole for his kitchen house.
His wife was expecting their first baby at any time. *Dani Tribe*

Elias

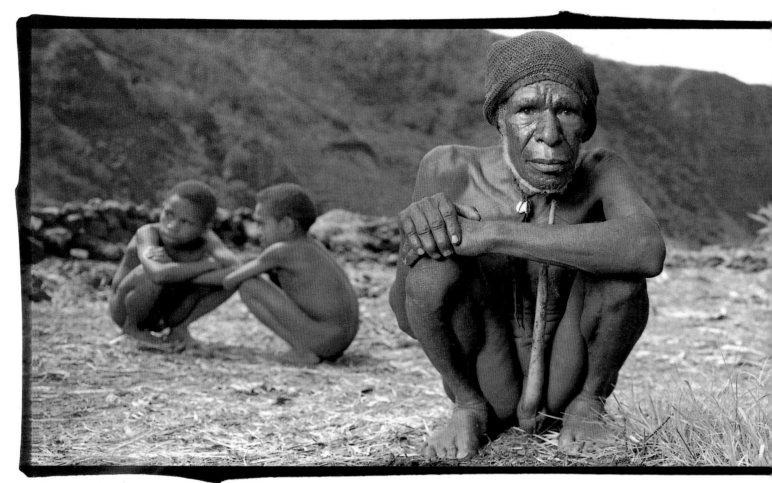

Jimeka, Irian Jaya

Yapali 58

YAPALI 58, JIMEKA, IRIAN JAYA (INDONESIA) Like other Dani men his age, Yapali bears the scars of many tribal conflicts. He said the conflicts were usually over women, coconuts, and pigs. Yapali was actually thankful that missionaries had come because they helped end the fighting. It's been less than 30 years since head-hunting, which Yapali once practiced, took place in the territory. As he talked, he punctuated his statements by flicking the end of his penis gourd with his finger. *Dani Tribe*

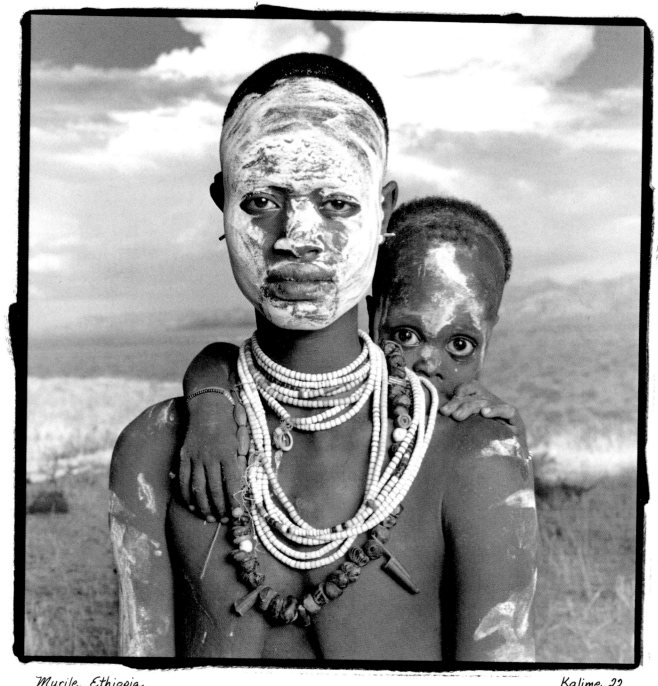

Murile, Ethiopia

Kalime 22
Algo 3

KALIME 22, ALGO 3, MURILE, ETHIOPIA Kalime and her son had just spent the day working in their cornfield. This year's drought has threatened both the growth of their crops and the survival of their entire tribe, the Karo. There are fewer than 500 Karo tribespeople remaining today. Kalime said they have had enough to eat this year but no one knows what the tribe will do if the rains don't come by next year. *Karo Tribe*

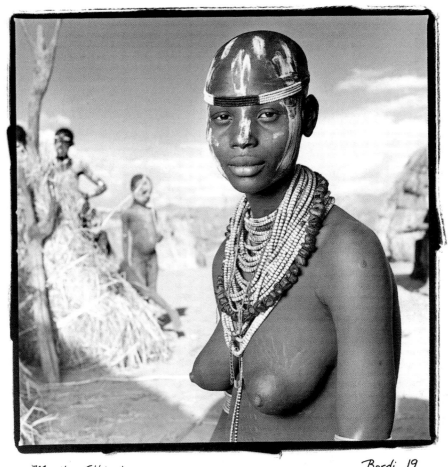

Murile, Ethiopia Bordi 19

BORDI 19, MURILE, ETHIOPIA Bordi is still nursing her first child, a son. Her bead pattern indicates that she is her husband's first and only wife.
As with most tribes, symbolism is very important, and jewelry, feathers and body scarification all convey specific messages.
The Karo are one of the most highly adorned tribes in the area. Their chief told me their traditions are most important to them; however,
he added that they still would like to be a part of the modern world. *Karo Tribe*

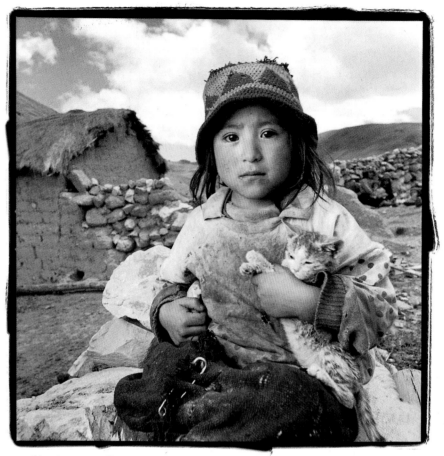

Chahuatire, Peru Leonarda 4

LEONARDA 4, CHAHUATIRE, PERU Several families were working in their communal potato field when I arrived at Leonarda's small village. Although only 4, she has the responsibility of herding the sheep. Cultivating, cooking, and home construction are done collectively in most Quechua communities. Even children who have just learned to walk can be seen helping in the fields by chasing birds away and covering the newly planted seeds. *Quechua*

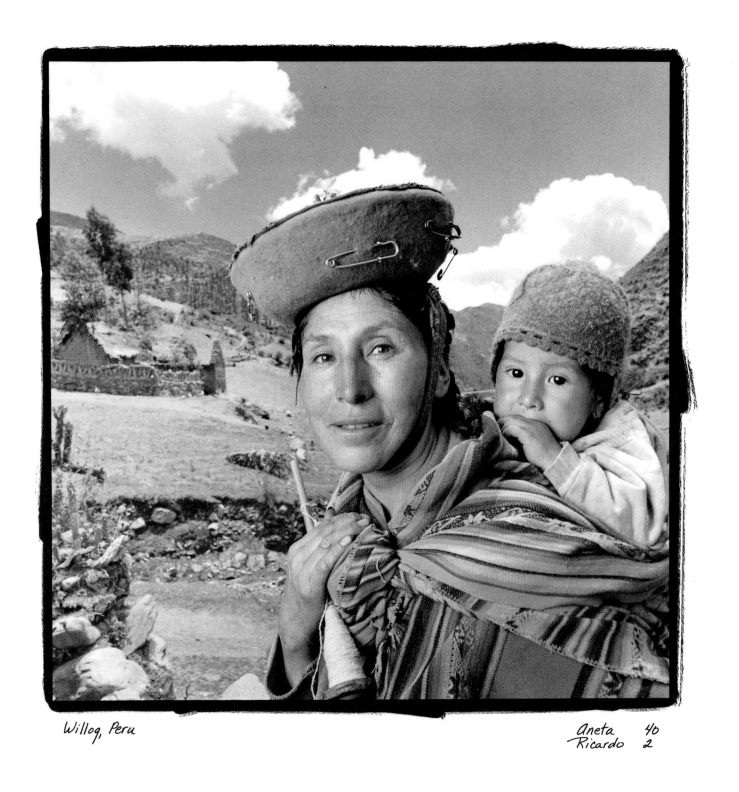

Willoq, Peru

Aneta 40
Ricardo 2

ANETA 40, RICARDO 2, WILLOQ, PERU Even though Aneta and her husband are illiterate, she insists that all 10 of their children will attend school. She is left alone for days at a time to tend to household responsibilities while her husband works as a porter for tourists on the Inca Trail. Fearing that she will become pregnant again, Aneta said that she might consent to the Peruvian government's new tubal-ligation program. *Quechua*

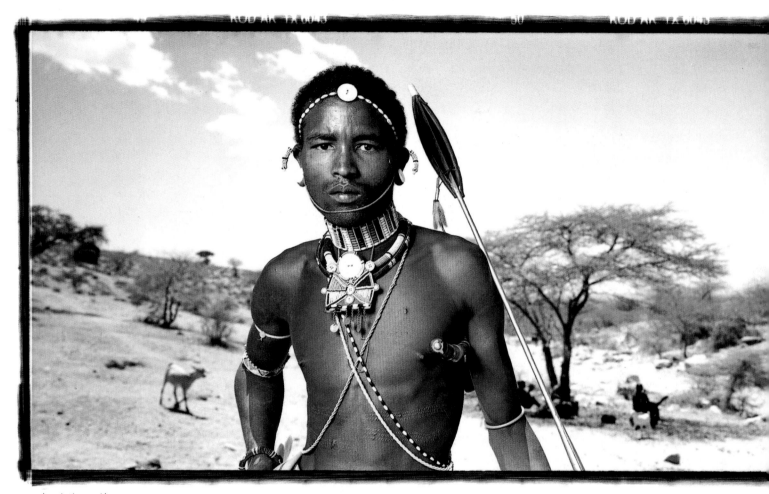

Lesirikan, Kenya

ROKET 17, LESIRIKAN, KENYA Roket was guarding the only well in the area to make sure no one took more than their share of water. He had just completed his circumcision ceremony and been initiated as a *moran* (warrior). The beadwork was handed down to him by an older *moran* who was getting married. I was told that if the initiate makes any sound or even slightly moves during the circumcision, he will be considered an outcast. In the past, he would be killed on the spot. *Samburu Tribe*

Roket 17

Jiwika, Irian Jaya

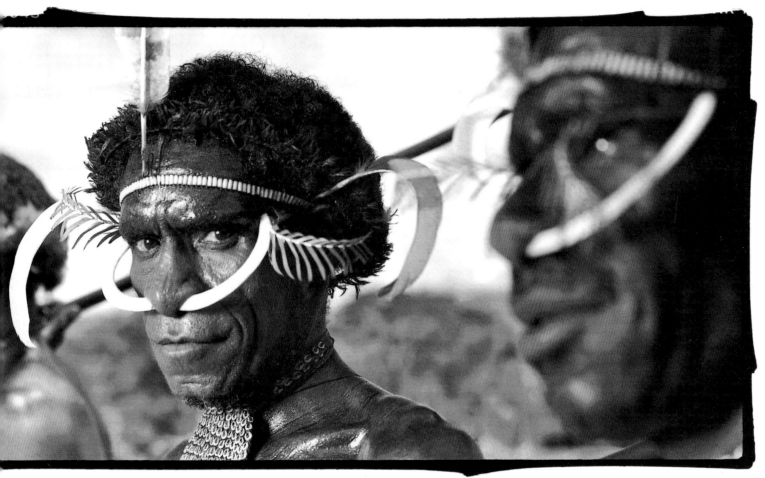

Giniban 50

GINIBAN 50, JIWIKA, IRIAN JAYA (INDONESIA) Although the Dani have all but stopped their ritual warfare, they continue to stage mock battles with other tribes. Giniban and some 30 of his warrior tribe members had just smeared their bodies with pig grease, donned their feathers, and picked up their spears for the afternoon event. The tribes are not really angry with one another—the battle just gives them a chance to let off steam. The Dani women fed their warriors lunch and cheered them on, and the battle ended when it started to rain. *Dani Tribe.*

WILLIAM PAWNEE 41, LEWISTON, IDAHO (UNITED STATES) William Pawnee came from Pine Ridge, South Dakota, to dance at the Four Nations Powwow in Idaho. "I've been dancing 18 years. The powwow connects me. Connects me to my ancestors—to the Creator. When I sing and dance, it's like joining a larger circle, a larger community. The powwow is the center, the heart. The drums are the heartbeat." *Oglala Lakota Tribe*

114

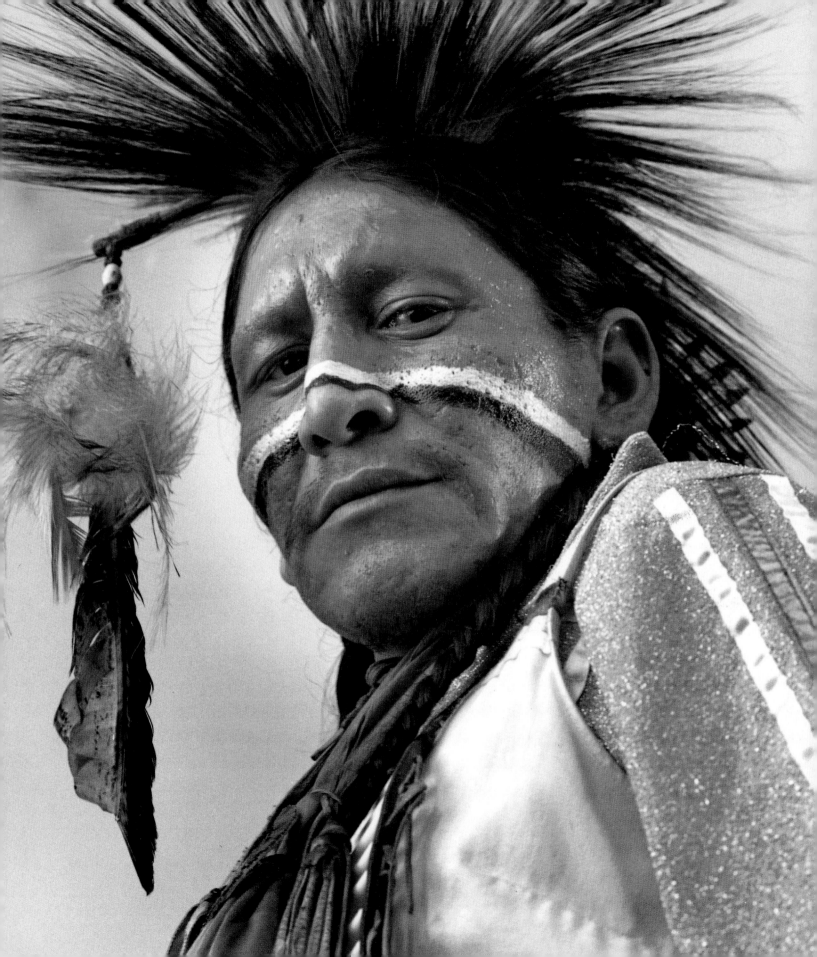

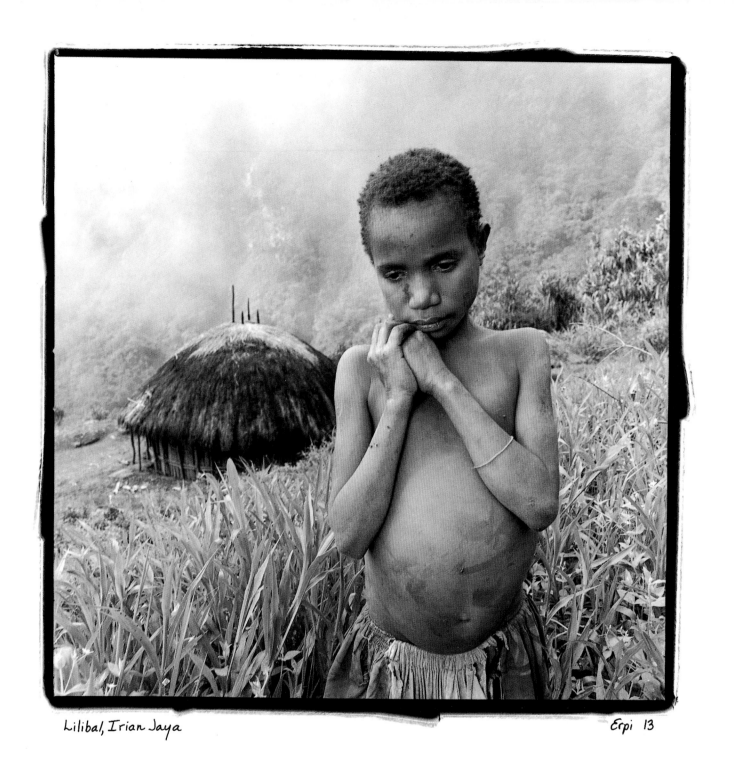

Lilibal, Irian Jaya

Erpi 13

ERPI 13, LILIBAL, IRIAN JAYA Because of recent tribal fighting, Erpi's schoolteacher has left Erpi's village and will not return until the conflict ends. Erpi tells me she loves school and is extremely disappointed. In the meantime, since she is not getting along with one of her father's wives, she has decided to move in with another family and help care for their children. Erpi's distended abdomen is probably caused by parasites rather than malnourishment. *Yale Tribe*

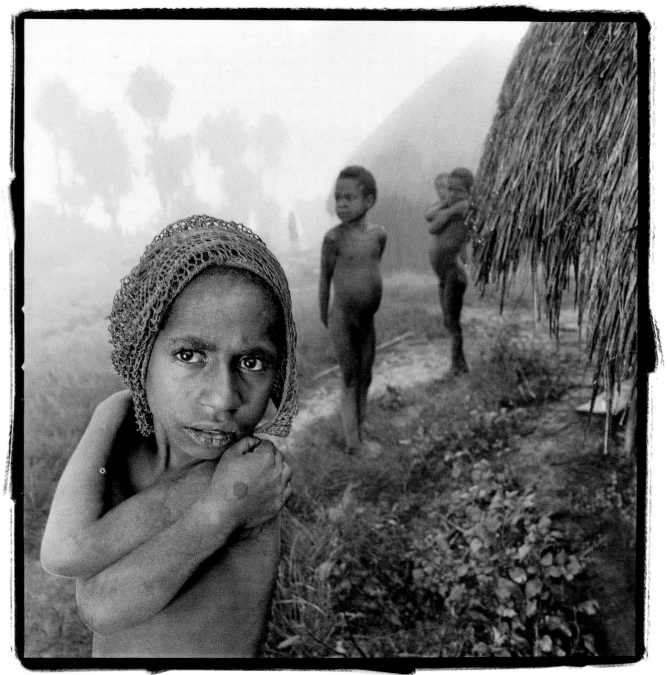

Lilibal, Irian Jaya Aniu 12

ANIU 12, LILIBAL, IRIAN JAYA (INDONESIA) Aniu and his friends had just run back to the village on this cold morning
after killing a very poisonous snake in the mountains. They said that just touching its skin could prove deadly.
They took me in back of their hut to show me several very large spiders that had spun their webs on prepared frames.
The webbing is harvested and worked into a fabric that is made into hats and bags.

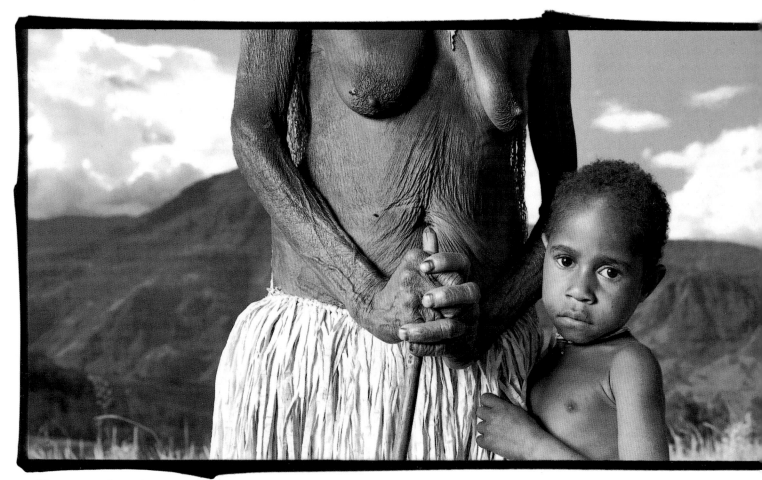

Noragara, Irian Jaya

MILIQUE 68, YASMINA 5, NORAGARU, IRIAN JAYA (INDONESIA) Yasmina is Milique's twelfth grandchild. For the past year, Yasmina has spent much of her time alone with her grandmother in their terraced garden, tending the sweet potatoes, garlic, and onions. Fourteen-hour days are not unusual. It is common among many tribal peoples to pair the young with the very old. People at these two stages of life are considered to have the most in common, since one has just left the spirit world and one will soon reenter it. *Loni Tribe*

Milique 68
Yasmina 5

Baragoi, Kenya

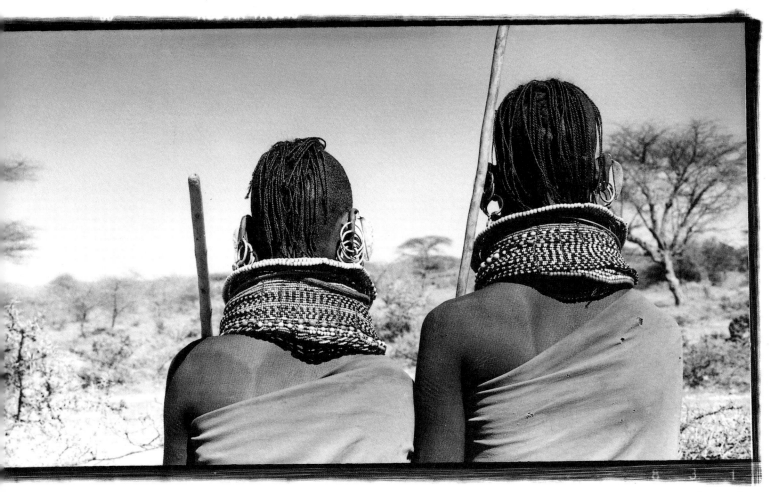

Echuka 24
Eragai 21

ECHUKA 24, ERAGAI 21, BARAGOI, KENYA Less than one month before, cattle raiders from the Sudan had come very close to Echuka and Eragai's small group of huts, or *manyatta*. Fearing for their lives, the two women took their children and ran out into the desert, hiding all night. In the last three years, Sudanese raiders armed with AK-47s have killed thousands of the Turkana in order to steal their cattle. Because the Turkana territory is so remote, this ongoing tragedy has scarcely provoked any international protest or publicity. *Turkana Tribe*

universal declaration of human rights

Adopted and proclaimed by General Assembly resolution 217 A(III) of 10 Dec.1948.

PREAMBLE **Whereas recognition of the inherent dignity and of the equal and inalienable rights of all members of the human family is the foundation of freedom, justice and peace in the world,**

Whereas disregard and contempt for human rights have resulted in barbarous acts which have outraged the conscience of mankind, and the advent of a world in which human beings shall enjoy freedom of speech and belief and freedom from fear and want has been proclaimed as the highest aspiration of the common people,

Whereas it is essential, if man is not to be compelled to have recourse, as a last resort, to rebellion against tyranny and oppression, that human rights should be protected by the rule of law,

Whereas it is essential to promote the development of friendly relations between nations,

Whereas the peoples of the United Nations have in the Charter reaffirmed their faith in fundamental human rights, in the dignity and worth of the human person and in the equal rights of men and women and have determined to promote social progress and better standards of life in larger freedom,

Whereas Member States have pledged themselves to achieve, in co-operation with the United Nations, the promotion of universal respect for and observance of human rights and fundamental freedoms,

Whereas a common understanding of these rights and freedoms is of the greatest importance for the full realization of this pledge,

Now, therefore, The General Assembly, Proclaims this Universal Declaration of Human Rights as a common standard of achievement for all peoples and all nations, to the end that every individual and every organ of society, keeping this Declaration constantly in mind, shall strive by teaching and education to promote respect for these rights and freedoms and by progressive measures, national and international, to secure their universal and effective recognition and observance, both among the peoples of Member States themselves and among the peoples of territories under their jurisdiction.

ARTICLE 1 All human beings are born free and equal in dignity and rights. They are endowed with reason and conscience and should act towards one another in a spirit of brotherhood.

ARTICLE 2 Everyone is entitled to all the rights and freedoms set forth in this Declaration, without distinction of any kind, such as race, color, sex, language, religion, political or other opinion, national or social origin, property, birth or other status.

Furthermore, no distinction shall be made on the basis of the political, jurisdictional or international status of the country or territory to which a person belongs, whether it be independent, trust, non-self-governing or under any other limitation of sovereignty.

ARTICLE 3 Everyone has the right to life, liberty and security of person.

ARTICLE 4 No one shall be held in slavery or servitude; slavery and the slave trade shall be prohibited in all their forms.

ARTICLE 5 No one shall be subjected to torture or to cruel, inhuman or degrading treatment or punishment.

ARTICLE 6 Everyone has the right to recognition everywhere as a person before the law.

ARTICLE 7 All are equal before the law and are entitled without any discrimination to equal protection of the law. All are entitled to equal protection against any discrimination in violation of this Declaration and against any incitement to such discrimination.

ARTICLE 8 Everyone has the right to an effective remedy by the competent national tribunals for acts violating the fundamental rights granted him by the constitution or by law.

ARTICLE 9 No one shall be subjected to arbitrary arrest, detention or exile.

ARTICLE 10 Everyone is entitled in full equality to a fair and public hearing by an independent and impartial tribunal, in the determination of his rights and obligations and of any criminal charge against him.

ARTICLE 11 / 1. Everyone charged with a penal offense has the right to be presumed innocent until proved guilty according to law in a public trial at which he has had all the guarantees necessary for his defense.

2. No one shall be held guilty of any penal offense on account of any act or omission which did not constitute a penal offense, under national or international law, at the time when it was committed. Nor shall a heavier penalty be imposed than the one that was applicable at the time the penal offense was committed.

ARTICLE 12 No one shall be subjected to arbitrary interference with his privacy, family, home or correspondence, nor to attacks upon his honor and reputation. Everyone has the right to the protection of the law against such interference or attacks.

ARTICLE 13 / 1. Everyone has the right to freedom of movement and residence within the borders of each State.

2. Everyone has the right to leave any country, including his own, and to return to his country.

ARTICLE 14 / 1. Everyone has the right to seek and to enjoy in other countries asylum from persecution.

2. This right may not be invoked in the case of prosecutions genuinely arising from non-political crimes or from acts contrary to the purposes and principles of the United Nations.

ARTICLE 15 / 1. Everyone has the right to a nationality.

2. No one shall be arbitrarily deprived of his nationality nor denied the right to change his nationality.

ARTICLE 16 / 1. Men and women of full age, without any limitation due to race, nationality or religion, have the right to marry and to found a family. They are entitled to equal rights as to marriage, during marriage and at its dissolution.

2. Marriage shall be entered into only with the free and full consent of the intending spouses.

3. The family is the natural and fundamental group unit of society and is entitled to protection by society and the State.

ARTICLE 17 / 1. Everyone has the right to own property alone as well as in association with others.

2. No one shall be arbitrarily deprived of his property.

ARTICLE 18 Everyone has the right to freedom of thought, conscience and religion; this right includes freedom to change his religion or belief, and freedom, either alone or in community with others and in public or private, to manifest his religion or belief in teaching, practice, worship and observance.

ARTICLE 19 Everyone has the right to freedom of opinion and expression; this right includes freedom to hold opinions without interference and to seek, receive and impart information and ideas through any media and regardless of frontiers.

ARTICLE 20 / 1. Everyone has the right to freedom of peaceful assembly and association.

2. No one may be compelled to belong to an association.

ARTICLE 21 / 1. Everyone has the right to take part in the government of his country, directly or through freely chosen representatives.

2. Everyone has the right to equal access to public service in his country.

3. The will of the people shall be the basis of the authority of government; this will shall be expressed in periodic and genuine elections which shall be by universal and equal suffrage and shall be held by secret vote or by equivalent free voting procedures.

ARTICLE 22 Everyone, as a member of society, has the right to social security and is entitled to realization, through national effort and international cooperation-operation and in accordance with the organization and resources of each State, of the economic, social and cultural rights indispensable for his dignity and the free development of his personality.

ARTICLE 23 / 1. Everyone has the right to work, to free choice of employment, to just and favorable conditions of work and to protection against unemployment.

2. Everyone, without any discrimination, has the right to equal pay for equal work.

3. Everyone who works has the right to just and favorable remuneration ensuring for himself and his family an existence worthy of human dignity, and supplemented, if necessary, by other means of social protection.

4. Everyone has the right to form and to join trade unions for the protection of his interests.

ARTICLE 24 Everyone has the right to rest and leisure, including reasonable limitation of working hours and periodic holidays with pay.

ARTICLE 25 / 1. Everyone has the right to a standard of living adequate for the health and well-being of himself and of his family, including food, clothing, housing and medical care and necessary social services, and the right to security in the event of unemployment, sickness, disability, widowhood, old age or other lack of livelihood in circumstances beyond his control.

2. Motherhood and childhood are entitled to special care and assistance. All children, whether born in or out of wedlock, shall enjoy the same social protection.

ARTICLE 26 / 1. Everyone has the right to education. Education shall be free, at least in the elementary and fundamental stages. Elementary education shall be compulsory. Technical and professional education shall be made generally available and higher education shall be equally accessible to all on the basis of merit.

2. Education shall be directed to the full development of the human personality and to the strengthening of respect for human rights and fundamental freedoms. It shall promote understanding, tolerance and friendship among all nations, racial or religious groups, and shall further the activities of the United Nations for the maintenance of peace.

3. Parents have a prior right to choose the kind of education that shall be given to their children.

ARTICLE 27 / 1. Everyone has the right freely to participate in the cultural life of the community, to enjoy the arts and to share in scientific advancement and its benefits.

2. Everyone has the right to the protection of the moral and material interests resulting from any scientific, literary or artistic production of which he is the author.

ARTICLE 28 Everyone is entitled to a social and international order in which the rights and freedoms set forth in this Declaration can be fully realized.

ARTICLE 29 / 1. Everyone has duties to the community in which alone the free and full development of his personality is possible.

2. In the exercise of his rights and freedoms, everyone shall be subject only to such limitations as are determined by law solely for the purpose of securing due recognition and respect for the rights and freedoms of others and of meeting the just requirements of morality, public order and the general welfare in a democratic society.

3. These rights and freedoms may in no case be exercised contrary to the purposes and principles of the United Nations.

ARTICLE 30 Nothing in this Declaration may be interpreted as implying for any State, group or person any right to engage in any activity or to perform any act aimed at the destruction of any of the rights and freedoms set forth herein.

meetings—in small places by PHIL BORGES

EVEN THOUGH I have been visiting indigenous people for more than twenty years, my initial contact with a new tribe still gives me a rush of excitement and intimidation. Traveling allows me to meet people whose lives differ substantially from my own. My camera gives me an excuse to be there—a reason to interact. Making a portrait, which in itself is a collaboration, allows me the privilege to enter the stories of other people. I love the whole process, especially since being with people of different backgrounds and customs helps me to uncover my own prejudices and presumptions.

AS A CHILD in the United States in the 1950s, drawing on stories from my parents and the news, I was deeply affected by how poor people were in the rest of the world. I began to define these "different" people mostly by what they lacked. Presumably they scraped by on meager diets of rice and beans, with no access to doctors, plumbing, electricity, and cars. We middle-class Americans had all these things in abundance. We should save them!

AS A YOUNG ADULT, I began to imagine indigenous people differently, and the pendulum swung to the other extreme. For a time I viewed them as romantic abstractions, all living in harmony with nature: mystics of Tibet, shamans from the Sierra Madres, stone-age tribes of New Guinea. It wasn't until I began to travel and to actually confront these images, these abstractions, that I found something else—real individuals. Individuals with a variety of personalities and temperaments, trying to fulfill basic needs—food, shelter, a sense of belonging, the need to contribute—that are common to us all.

LAST SUMMER, for example, I hiked for two weeks into the jungles of Irian Jaya and found myself in a village surrounded by men wearing nothing but penis gourds and pig tusks. At a distance they looked exotic and somewhat intimidating. However, after two or three hours, their strangeness began to fade, and their mannerisms started to capture my attention. The emotional life that registered on their faces was so familiar to me. I recognized the body language and facial expressions of individuals I knew back home. In the end, it was not their differences that impressed me but their similarities. I have experienced this repeatedly in the remote corners of Africa, South America, and Asia. In spite of our physical and cultural differences, we are all, in a very basic sense, alike!

WITH FEW exceptions, my encounters with the people I photograph are facilitated by an interpreter/guide. Depending on the situation and the language, two interpreters may be required. Understanding is gradual and halting and tempered by the necessary approximations of the translated word. Typically, I approach my subject and communicate with body language as much as possible, then ask my interpreter to explain that I intend to use these photos in a book. In most cases, I pay to photograph each individual, and I try to bring gifts for the tribe. It is not uncommon for a person to double the pre-agreed rate for his or her portrait

after I am finished. More often than not, this person will not even keep this money, but will instead share it equally with relatives and friends.

INDIGENOUS PEOPLES have been threatened for centuries by governments and individuals hungry for their land and resources. They face political repression, encroachments on their environment, disease, famine, drought, and other scarcities. Many non-governmental organizations work to bring exploitation and repression into the light of global scrutiny. Unfortunately, these cultures face another, more insidious peril. Exposed to images of wealth and power, many of the young are turning away from their elders, breaking an ancient but fragile chain of oral traditions and knowledge. On any given day, I can leave my home in Seattle and within forty-eight hours be in the midst of some of the most "isolated" tribes on earth. I have found magazine photos of cars and bikini-clad women on the walls of mud huts in remote areas of Africa, and Nike T-shirts on warriors in the jungles of New Guinea. Cultural isolation is no longer a reality or an option.

ON THE ESSENTIAL issues of human rights, there is a need for nuance and subtlety when attempting to effect solutions across cultural lines. I have observed how imposed changes can produce counterproductive results that were not anticipated. In negotiating between sometimes conflicting positions, it is helpful to have a guide, and the Universal Declaration of Human Rights provides one. In fact, it is the first and only internationally ratified document that sets global human rights standards.

I AM HONORED to have the images in this book associated with the 50th anniversary of the Universal Declaration of Human Rights. One of the great challenges of our time is to bring all people together in a global community in which diversity of body, mind, and spirit can safely exist. An informed respect for difference is at the center of this vision.

HOWEVER, UNIVERSAL human rights will remain an almost unreachable abstraction unless we approach it in small meetings, on an intimate scale. Eleanor Roosevelt understood that human rights must be meaningful in "small places…so close and so small that they cannot be seen on any maps of the world." Face-to-face encounters provide a small opening where the work of mutual recognition can begin. This collection of portraits is my attempt to put a face on some of the abstractions, to sidestep generalizations and romantic fantasies, and to present these people as individuals—as our contemporaries.

THESE ARE JUST some of the people I have met. Some are experiencing their first contact with the outside world; some have survived exploitation and repression for years; some whose cultures have been decimated are attempting a comeback—people trying to hold on to their identities at the fragile edge of the expanding mainstream.

epilogue by WILLIAM F. SCHULZ

Executive Director, Amnesty International USA

ROBERT FROST once said that poems begin with a lump in the throat. Human rights do, too. And they have done so for almost four thousand years, at least since 1740 BC, when King Hammurabi codified his laws against unfair trials, torture, and slavery. At the end of the day, the reason any one of us cares about human rights is that we feel sick at heart at the sight of misery.

BUT IT WAS not until 1948—December 10, 1948, to be exact, 3,688 years after Hammurabi's legislation—that the people of the world managed to agree formally and in writing that equal access to fundamental freedoms mattered: freedom of speech and belief, and freedom from fear and want. That day, the member states of the United Nations adopted the Universal Declaration of Human Rights (UDHR), an international bill of rights for all people.

THE UDHR contains thirty articles delineating such entitlements as the right to a fair trial, to free opinion, to just working conditions, to education and adequate housing, and the right not to be tortured or held in servitude. It took the fifty-eight nations that helped to draft the document a long time to agree on every word, phrase, and punctuation mark (Eleanor Roosevelt played a key role as chair of the United Nations Human Rights Commission). But finally, having agreed to the document and having ratified it—a document by which every nation that joins the United Nations implicitly agrees to abide—the world had accomplished something very special.

THE UDHR is a revolutionary document, even fifty years after its passage. It is revolutionary first by the very fact that it is universal, the work of all the nations and cultures of the world; not just that of the French, for example, as in the Declaration of the Rights of Man and of the Citizen; not just that of the United States, as in the U.S. Constitution's Bill of Rights.

BY VIRTUE OF their universality, the rights articulated in the UDHR trump every political ideology, every cultural practice, every parochial claim. In an age when appeals to "Asian values" or "respect for cultural diversity" have been used to justify everything from harassment of journalists and systematic political torture to bride-burning and female genital mutilation, the UDHR provides a benchmark against which to measure the world's most questionable practices.

THE UDHR is revolutionary also precisely because it is a declaration, not a revelation. Before the existence of the UDHR, people had argued for the protection of human rights on one of two grounds: either God wanted it or Nature's law required it. Fortunately, the UDHR is not a revelation of either God or Nature's predilections but a declaration by the world community of a promise it has made to itself, a covenant entered into by the nations of the world with one another to order human life in a certain fashion. And that is what rights are— promises to which we can appeal in the face of affronts to human dignity.

NOW, does the UDHR have the force of law? It was not originally intended to. Back in 1948, the United States was one of the countries most vociferously opposed to any implication that the Universal Declaration constituted an enforceable guarantee. The U.S. State Department called it a "hortatory statement of aspirations." But over the years that exhortation has laid the groundwork for legally binding human rights treaties; it has been cited by courts and incorporated in one fashion or another into ninety national constitutions, until today it is regarded as customary international law.

BUT IN MY judgment the legal standing of the UDHR is less important than its mythic status. Ask of any of the world's sacred texts what makes us human and how our lives should be ordered and every one of them—religious texts like the Bible or the Koran, or political or cultural documents like the Magna Carta or the Analects of Confucius—will provide us answers. Yet every one of them is also associated with an idiosyncratic tradition. Only one "sacred text," the Universal Declaration of Human Rights, cuts across every boundary, every margin, and every faith; tackles two of the most controversial subjects in human history (the nature of humanity and the ethics of a civil society); and still man-

ages to claim the fealty of every quarter. That is an astonishing achievement, one worth celebrating every year.

THE BOOK you hold in your hands contains Phil Borges's work, the visual embodiment of the UDHR. These photographs say more powerfully than any document ever could that rights and values, misery and triumph, extend to every corner of the world. For the aspirations and commitments expressed in the Universal Declaration speak directly to the lives of those whose faces peer into Phil's camera. Be it the struggle of female children and women to match their status with their dignity; be it the age-old effort to wrest some kind of plenitude out of paucity; be it the celebration of rituals that make our lives worth living; present in all these instances, in every setting Phil has pictured, is the idea that human beings, merely by virtue of their humanity, can claim a set of rights; and this idea offers gladness, hope, and liberation.

IN PHIL BORGES'S hands and in Isabel Allende's words—eloquent words which place the photographs in both personal and global contexts—the Universal Declaration of Human Rights becomes electric, leaps off its pages, buries itself in the human heart and burns there.

AMNESTY INTERNATIONAL is immensely proud to be associated with this endeavor. Founded in 1961 to promote all aspects of the UDHR, Amnesty is devoted specifically to ending torture, political killings, disappearances, unfair trials, and executions. Those are some of the things we are against—the misery that leaves lumps in our throats. But the photographs in this book testify as well to what we are for: preserving the public space, and creating the practical opportunity, for human beings to find fulfillment in their lives.

THE BATTLE for human rights has changed much since the UDHR was first written and Amnesty was first founded: governments have become more devious; massacres have become more common; economics has become a more dominant force; the world has become more complicated. But ultimately Amnesty's calling and that of all the friends of human rights is much the same as it ever was.

WILLA CATHER once wrote, "What is any art but a sheath in which to try to capture that shining, elusive quality which is life itself, hurrying past, too swift to stop, too sweet to lose?" It is certainly true that much of what causes human misery, including death itself, is often too swift to stop. But our job is to keep it waiting, waiting just long enough that the people of the world, too sweet to lose, might finish their dance. Surely there is no job more honorable than that.